X

||||| ||| |||| ||| ||| ||| |||| |||
D0493506

759·08 TAT

WITHDRAWN

FORTY YEARS OF MODERN ART 1945-1985

Wimbledon School of Art

|||||| ||| ||| ||| ||| ||| ||| |||
54039000004237

FORTY YEARS OF
MODERN ART 1945-1985

THE TATE GALLERY

front cover
David Hockney, **A Bigger Splash** 1967

photographic credits
John Webb
Tate Gallery Photographic Department
Lisson Gallery, London

The following works are © ADAGP 1986
Nicolas de Staël p.32, Hans Hartung p.33,
Jean Dubuffet pp.45–8, Pol Bury p.68,
Yves Klein p.70

The following works are © COSMOPRESS,
Geneva/ADAGP, Paris 1986
Alberto Giacometti pp.40–3, Josef Albers p.66

The following works are © DACS 1986
Constant p.34, Victor Vasarely p.65, César p.71,
Arman p.73, Carl Andre p.81,
Robert Rauschenberg p.94, Jasper Johns pp.95,
105, Roy Lichtenstein p.96, Andy Warhol p.97

ISBN 0 946590 36 2 (paper)
ISBN 0 946590 37 0 (cloth)
Published by order of the Trustees 1986
for the exhibition of 19 February – 27 April 1986
Copyright © 1986 The Tate Gallery All rights reserved
Published by Tate Gallery Publications,
Millbank, London SW1P 4RG
Printed by The Hillingdon Press, Uxbridge, Middlesex

Contents

Foreword

Museum visitors have grown accustomed to seeing loan exhibitions whenever they visit the great national galleries, and the Tate Gallery has been foremost in providing them. Admirable though this policy is, it does however tend to put the display of the permanent collection into a subsidiary role – regarded as an attraction for the first time visitor, whether from this country or abroad, but not as something that will inspire repeated visits. This is most regrettable, because it is the permanent collection of the Tate Gallery that is its *raison d'être*.

Unfortunately the Modern Collection is not displayed as fully as it should be, and this is particularly true of the art of the last forty years. The reason for this is the acute shortage of space from which the Tate suffers – it is the most serious single problem that faces the Gallery. The opening of the Clore Gallery next year and of the Tate Gallery in Liverpool in 1988 will certainly help, but further development of the Millbank site becomes increasingly urgent. We have the space; we now have the splendid outline designs for the museums of sculpture and of new art from James Stirling, Michael Wilford and Associates. We know that this is a development that our public wishes to see, and one that is necessary if the Tate Gallery is to fulfil its proper function as the national collection of modern art. What must be found is the finance to make these plans a reality.

Forty Years of Modern Art 1945-1985 is both a publication and an exhibition about the Tate Gallery's holdings of the painting and sculpture of the second half of the twentieth century. The display fills the space normally given over to loan exhibitions, and serves both as a review of what has happened in art since the end of the second world war, and as an opportunity to assess the strengths and weaknesses of the Tate collection.

In this period since 1945 the Tate Gallery's Modern Collection has been totally transformed, under the directorships of my predecessors, Sir John Rothenstein, up to 1964, and Sir Norman Reid, up to 1979. The Tate Gallery is now universally recognised, not only for its historic British paintings, but also as one of the world's great museums of modern art. Though there have been very many generous gifts and bequests, this has been achieved essentially through a steady increase in the funds made available by successive governments. A grant for acquisitions was first made in 1946, at a figure of £2,000 a year, (and this grant is of course for all acquisitions, not just those of modern art). The sum available had been increased to £40,000 by 1960, and to £265,000 by 1970, reaching a peak of £1,888,000 in 1980 – a level at which the purchasing grant of the Gallery unfortunately remains, despite the enormous increase in prices of works of art.

A considerable part of these state-provided acquisition funds has gone towards the purchase of paintings and sculptures by the great masters of early modern art. A single major work of museum quality by these artists can now cost over £1 million; it is clear that the Gallery acted only just in time. In a less systematic way, the Gallery has also been building up a collection of art of the second half of the twentieth century, and it is this that is offered for public scrutiny at the moment. It is a part of the Tate Gallery's responsibility to ensure that we have outstanding examples of all the significant artists and movements that have emerged since the last war. Only in this way can we avoid a repetition of the errors of omission made in the past.

There is still much to be done in building up the post-1945 collection. Certain movements and artists are however well represented in the Tate Gallery, which has in some cases – particularly where British art is concerned – the key works. The American Abstract Expressionist group is the best outside any museum in the United States; some major European figures, notably Giacometti, Dubuffet and Bacon, can now be very comprehensively shown. In such cases the hindsight of history supports our judgements. With more recent art, controversy and disagreement are inevitable. In my own view when we choose to represent an artist in the collection, we should go all out for a major statement. There have been too many half-hearted acquisitions in the past, and these have left us with some of the gaps that are now most difficult to fill. Such recent purchases as the Kiefer 'Parsifal' triptych or Julian Schnabel's 'Humanity Asleep' need no apology.

This book and exhibition also celebrate two notable events which should not pass unrecorded. One is that the Friends of the Tate Gallery have now given us over £1 million in cash towards the acquisition of works of art, quite apart from the many gifts and bequests that have come through them. For more than twenty-five years, the Friends have been unstinting in their support of the Gallery's acquisition policies, and this continues, as exemplified both in the recent gift of Bridget Riley's 'Hesitate' of 1964, and in the works being chosen and donated by the Patrons of New Art. These generous gifts from our Friends are indicated both in the catalogue and on the picture labels, and we are indeed indebted to them.

The second event is the retirement in March 1986 of Ronald Alley. Mr Alley came to the Tate in 1952 after graduating from the Courtauld Institute. He has spent his entire professional career here, becoming Keeper of the Modern Collection in 1965. He has watched over and participated in the extraordinary growth of the collection, and it seemed entirely appropriate to invite him on

his impending retirement to select and hang all the exhibition galleries with the work of this period, and to write this guide to the collection for the benefit of future visitors. Mr Alley has always shown total devotion to the Tate's Modern Collection, and what we see today owes not a little to his disinterested but passionate activities. If I may single out one aspect, of which the general public may not be aware, it would be the cataloguing of that collection. He has set a standard for his younger colleagues that is admired the world over: his own scholarly catalogue of the Gallery's non-British collection (which was published in 1981) and his contributions to the Gallery's biennial catalogues of acquisitions are exemplary, and can never be replaced. Though he leaves the Gallery, he will always be remembered with affection and gratitude.

Alan Bowness *Director*

Introduction

The early part of this century was a time of unprecedented inventiveness in art, leading to the creation of a succession of great movements, such as Fauvism, Cubism, Futurism, Dada, Surrealism and Expressionism; but by 1945 most of these seemed to be largely exhausted, and the field which appeared to offer the greatest possibilities for further development was abstract art. Thus abstract art, in a great variety of forms, has been the dominant idiom of the post-war period.

Whereas the course of art in Europe had been savagely disrupted by the war and in some countries took years to recover, art in the United States actually benefited directly from it through the arrival of a number of the greatest European artists as refugees. Although the majority of them returned to Europe soon after the war ended, their presence helped to generate an atmosphere of great excitement and vitality very different from that in Europe at the time, and the Surrealists' practice of automatism was taken up by a group of American abstract painters and played a key role in the development of Abstract Expressionism. This new, freer and more improvisatory type of abstract art, larger, grander and more daring than its post-war School of Paris equivalent, had great impact in Europe when it began to be widely known there from about 1955 onwards, and was largely instrumental in establishing New York as the main creative centre for painting instead of Paris. Free from the constraints of tradition which seemed to inhibit so many European artists, artists of the post-war American school have continued to show extraordinary freshness and boldness; and they have been supported by an exceptionally powerful body of dealers and collectors.

In their search for new forms of art which would avoid the stale imitation of what had been done before, many artists of the post-war period have attempted to go back to the basics of art, the very beginnings, in order to make a fresh start. Abstract Expressionism, with its emphasis on improvisation and the process of painting – on painting as an act of discovery and self-exploration – was conceived partly in this spirit. Others have sought to reduce art to a few, very simple elements. Yves Klein, for instance, worked with completely monochrome canvases to give the purest possible sensation of colour, while Lucio Fontana slashed the picture surface with a razor blade, and Victor Pasmore started afresh with a basic vocabulary of forms such as the circle, square, triangle and spiral. It is not by chance that some of the most radical post-war abstract movements have had names like Nul and Zero, indicating the artists' intention to try and start again from a tabula rasa. At the same time other artists of a more figurative kind such as Dubuffet, Jorn and Appel have

been influenced by the art of children or the insane, that is to say the most spontaneous and instinctive artistic expressions. Their images consequently have a grotesque and primitive character.

The post-war world, with its advertisements, television, films, magazines, pin-ups, pop stars and so on, in turn provided artists with a new range of vivid imagery which some of them have been eager to use in their works. This is apparent above all in the work of the Pop artists, who sometimes copied images from advertisements and the like with little modification. Even an artist such as Francis Bacon, in his paintings of the 'forties and 'fifties, often based his images partly on newspaper photographs or film stills. Some artists, such as the French Nouveaux Réalistes, incorporated actual machine-made objects of a mass-production kind in their works, either by a process of assemblage or by using them as scrap material which could be radically reshaped.

Although Abstract Expressionist paintings are often highly dramatic, with a strong emotional charge, much of the abstract art which came afterwards has been of a more detached and cerebral kind. The 'cool' abstract art which developed in the 1960s reflected the more relaxed mood of the time, and included Minimal sculptures not actually made by the artists themselves but fabricated by industrial craftsmen from their designs.

The growing emphasis on the ideas behind the work culminated in Conceptual Art, and a variety of activities such as temporary installations and performances, and the exploration of different types of system, which often left no permanent record except for documentation in the form of texts, photographs or videos. In extending the frontiers of their art in this way, artists seemed to be departing further and further from painting and sculpture as these had been traditionally understood. (Even though some of the photographs, it must be said, have a strong visual impact).

The latest movement, a return to painting and to figuration of a vigorous, neo-expressionist kind, is in part a reaction against these extremes.

When I was given the opportunity to put on this exhibition of the Tate's collection of art of the last forty years, it seemed to me that the best way to make use of the space was to leave out the work of the great pre-war artists who lived on into the post-war period, such as Picasso, Matisse, Léger, Miró and also their British counterparts, and to concentrate on the new artists and new movements which have emerged since the war. (Though late works by Picasso and some of the others are on view in the galleries leading up to the exhibition). Although some of them continued to produce very fine works

right up to the end of their lives they did not, in general, have much continuing influence on younger artists and the course of art.

Another decision was to try to give each space a distinctive character by devoting it either to a single movement or a couple of related movements, or to a single major artist who was particularly well represented in the collection. It was my hope that by arranging the exhibition in a reasonably chronological sequence, visitors as they walked through the exhibition would get some feeling of the changing character of art over the period, and also an impression of the excitement which those of us felt at the time who followed the development, the unfolding of art with close, eager attention. Unfortunately the space available was much too limited to include all the artists I wanted to put in, and I have had to be harshly selective in some areas. The fact that so much post-war art has been extremely large means that one can easily fill a whole room with a very small number of works. I should have liked to devote one of the spaces to Francis Bacon, but as seven of the Tate's paintings by him are still away on tour in the Bacon exhibition this is sadly impossible; and a few other works, such as the 'Cubi' sculpture by David Smith, are also unavailable for similar reasons.

The Tate's collection of this period was built up at a time when we were also trying to form, from a very low base, a fully representative coverage of the art of the earlier part of this century, and we were therefore only able to devote a portion of our funds to it. Nevertheless I believe that visitors, even those who know the Tate Gallery well, are likely to be surprised by the strength and quality of what we have. Perhaps the exhibition will help to bring home to people how desirable it is that further buildings be erected on the Millbank site, so that a display like this, and more, can be on view all the time.

Ronald Alley

American Abstract Expressionism

The first great new art movement to emerge after the war was American Abstract Expressionism, which was also the first major new movement to originate in the United States. A number of the artists had come to know one another during the Depression years of the 1930s when they were employed by the Works Progress Administration (part of Roosevelt's New Deal) on such projects as painting murals for post offices and airports. Although the style in which the majority of WPA artists were working at the time was a kind of Social Realism, Pollock was drawn more to Picasso and the Mexican muralist Orozco, while Gorky was influenced by Picasso and Miró.

A factor of crucial importance was the arrival in the United States as refugees from Europe, just before and during the early years of the war, of a number of the greatest European artists such as Mondrian, Léger and Chagall, and in particular the majority of the most important Surrealists including the poet André Breton, the founder of the movement, and Ernst, Duchamp, Dali, Masson, Tanguy and Matta. From about 1941 to 1945 New York became the international centre of the Surrealist movement. Although Gorky was the only one of the future Abstract Expressionists to become closely associated with the Surrealist group, the Surrealists' practice of automatism – a process whereby the images in paintings were allowed to develop out of a kind of spontaneous doodling – became a technique of great importance to Pollock, de Kooning, Motherwell, Baziotes, Gorky and various others, and enabled them to free themselves from too great a dependence on previous paintings and to break into entirely new territory.

Instead of beginning a painting with a clear-cut idea of what they wanted to do, they would make a few marks which would suggest other marks, so that the image would arise as they went along and the paintings could change unpredictably several times over in the course of execution. This resulted in such masterpieces of improvisation as Jackson Pollock's large drip paintings executed with the canvas laid flat on the ground, and with the artist moving around it and dripping rhythmical interweaving trails of paint from a brush or stick, but nevertheless achieving a complex, completely integrated design. One of the names given to this type of painting was Action Painting because of the way the artist's brushstrokes and other paint marks seemed to be a re-cord of his activity on the canvas. But although conspicuous, expressive brushwork is characteristic of certain types of Abstract Expressionist painting, particularly the work of Franz Kline, de Kooning and Pollock, there are also other types in which the paint is applied more evenly and

unobtrusively to create over-all fields of colour. Rothko's hovering soft-edged colour patches are examples of this, but the most extreme work of this kind was produced by Barnett Newman, with his large uniform colour fields interrupted and animated only by two or three narrow vertical bands or 'zips' of contrasting colour.

Much of the work produced by the Abstract Expressionists was on a very large scale, related to the height and reach of the human figure, and has extraordinary boldness and a dense saturation of colour. The artists deliberately sought drama and grandeur of effect and impact.

Pioneered in the early 1940s by Pollock, who was the first to paint pictures which were entirely unlike anything that had been seen before, the movement soon attracted more and more adherents, and probably reached its peak about 1946-52: this was the period when artists like Rothko, Gottlieb, Still, Newman, Guston and Reinhardt produced their first fully characteristic Abstract Expressionist works.

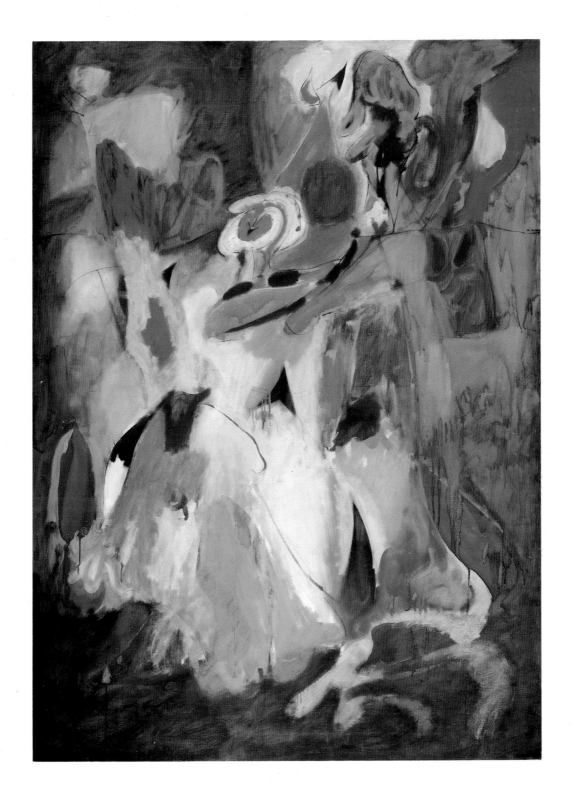

Arshile Gorky, **Waterfall** 1943

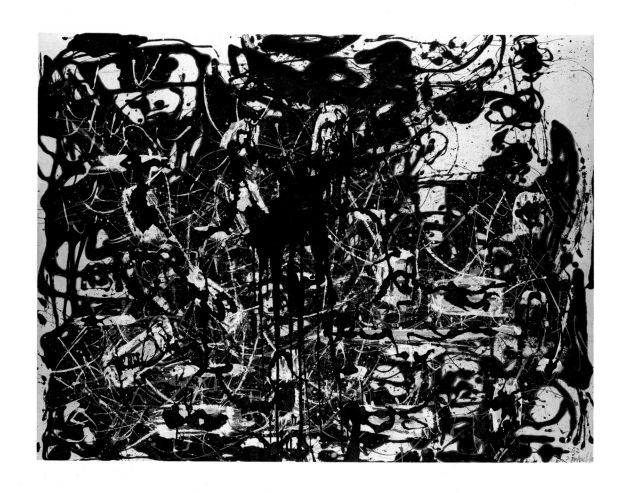

Jackson Pollock, **Untitled (Yellow Islands)** 1952

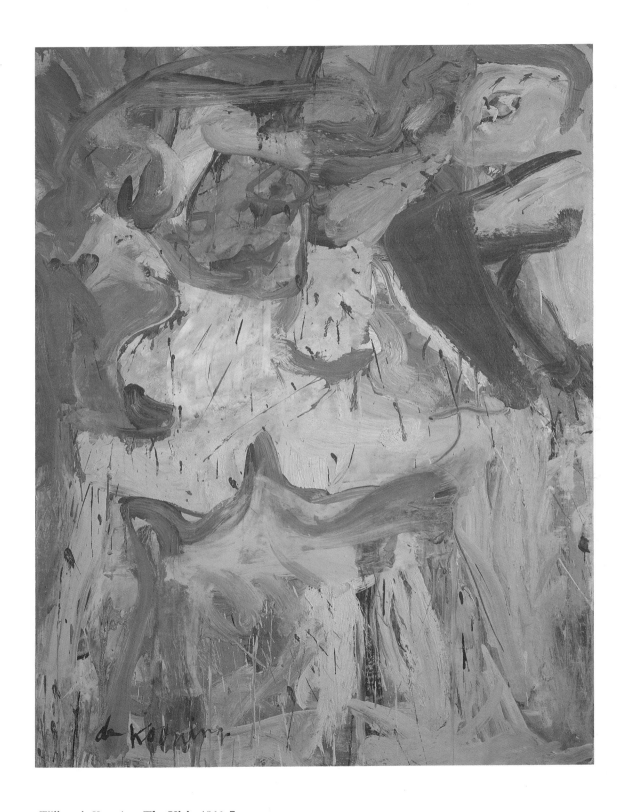

Willem de Kooning, **The Visit** 1966-7

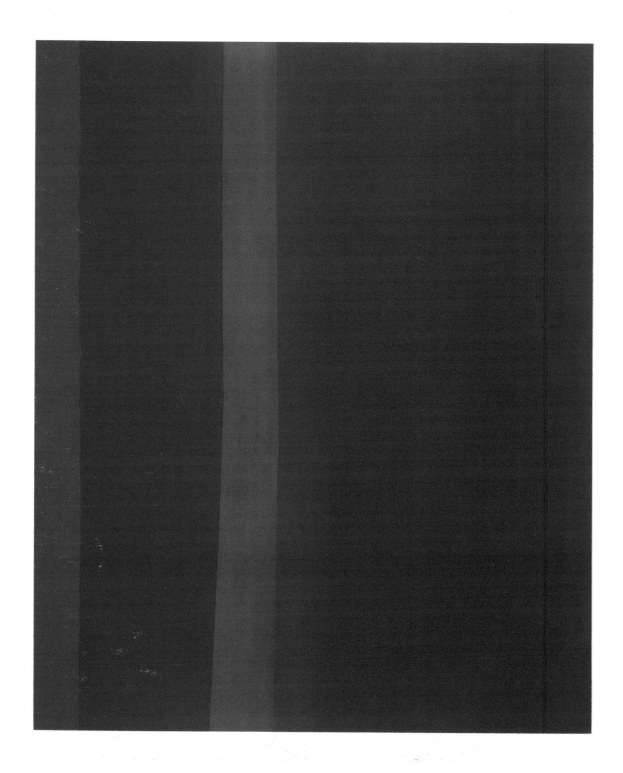

Barnett Newman, **Adam** 1951-2

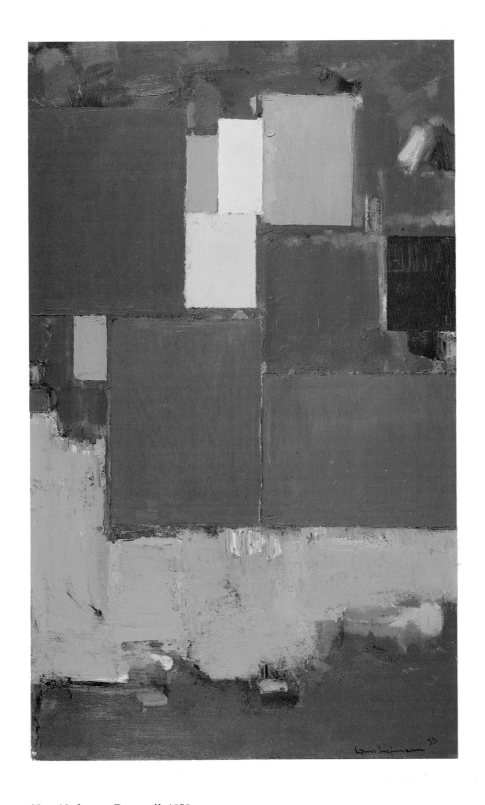

Hans Hofmann, **Pompeii** 1959

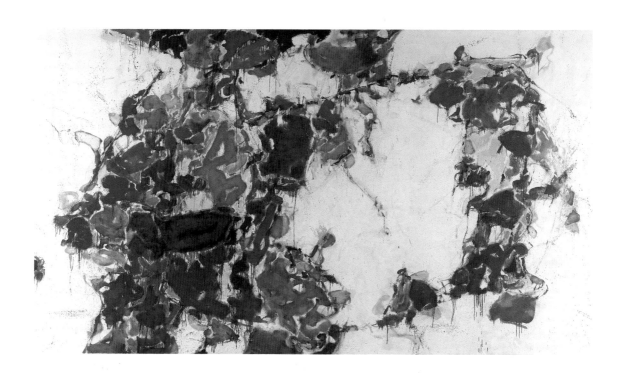

Sam Francis, **Around the Blues** 1957/62

Europe at the End of the War

Unlike the United States, much of Europe emerged battered and exhausted at the end of the war. In most countries there were extensive areas of devastation to be rebuilt and a widespread shortage of raw materials. Even in Britain rationing continued long after the war (clothes rationing until 1949 and meat rationing until 1954), and the conditions of austerity did not begin to lift significantly until the Festival of Britain in 1951. Existentialism, with its deep vein of pessimism, exercised a strong influence on intellectuals in France, while in Germany cultural life had been almost totally disrupted by the Nazis and the war and took a long time to recover. In Italy the Communists nearly came to power, and Guttuso's 'The Discussion' is a reflection of the intense ideological disputes of the time.

Having lived through such a violent life–and–death struggle, there was at first a feeling in many quarters that abstract art was too purely aesthetic, too cut off from life, and that art should deal with real people and real issues and be readily understandable. Thus the work of the so-called 'kitchen sink' artists in Britain, like Bratby and Jack Smith, without being overtly political, was based on the impecunious way they were themselves living at the time (and had its counterpart in literature in such works as Kingsley Amis's *Lucky Jim* and John Osborne's *Look Back in Anger*). The drabness of daily existence was reflected in the art. In addition, there was a great shortage of information about artistic developments elsewhere, caused both by restrictions on foreign travel and by the fact that there were few periodicals dealing with contemporary art and relatively few international exhibitions, so that, for example, very little was known in Europe about the American Abstract Expressionists until as late as the second half of the 1950s. (Some of the artists whose work was then almost Social Realist, like Jack Smith, have since become distinguished abstract painters).

As far as sculpture was concerned, a particularly significant event was the International Sculpture Competition 'The Unknown Political Prisoner' which was announced in January 1952 and attracted some 3500 entrants from fifty-seven countries. After preliminary selections had been made by the national juries, the 140 shortlisted maquettes were exhibited at the Tate Gallery in March–April 1953, when the Grand Prize was awarded to Reg Butler.

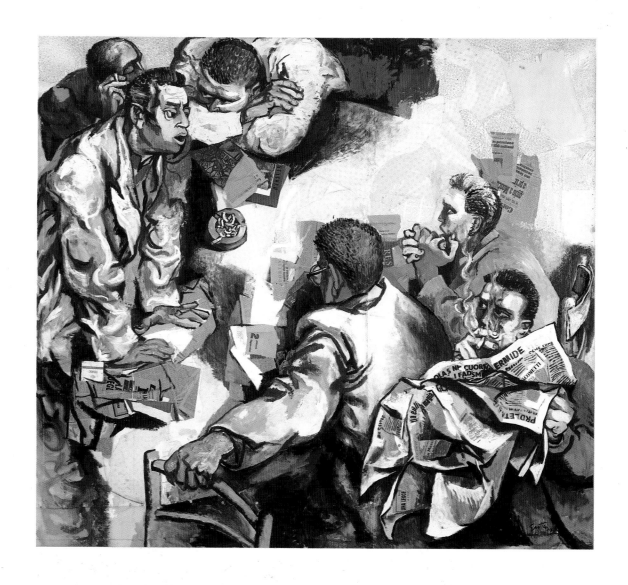

Renato Guttuso, **The Discussion** 1959-60

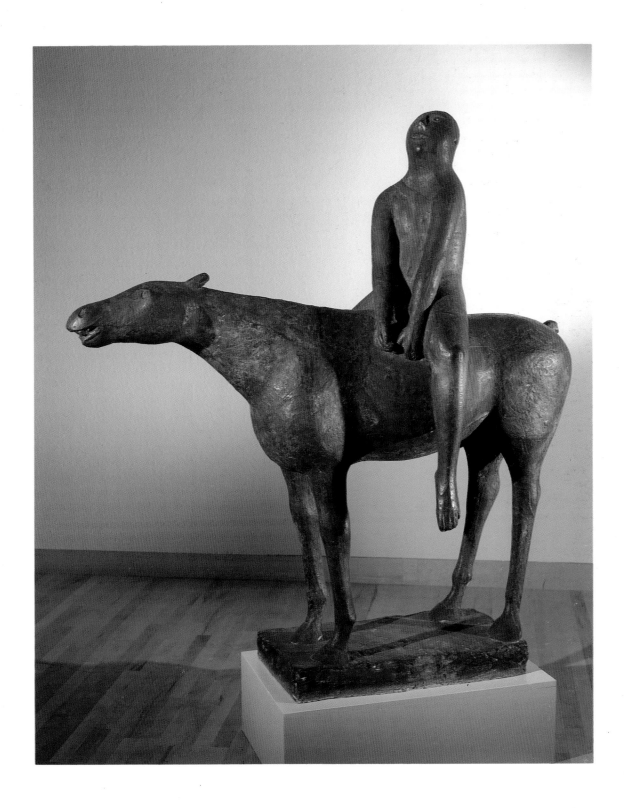

Marino Marini, **Horseman** 1947

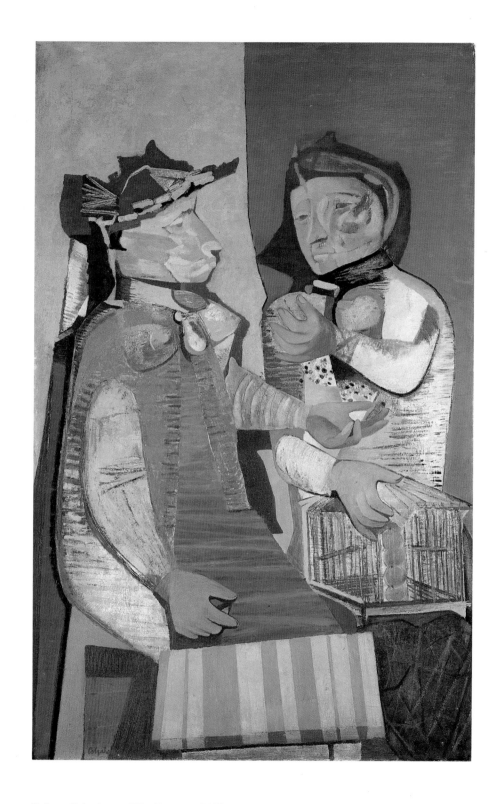

Robert Colquhoun, **The Fortune Teller** 1946

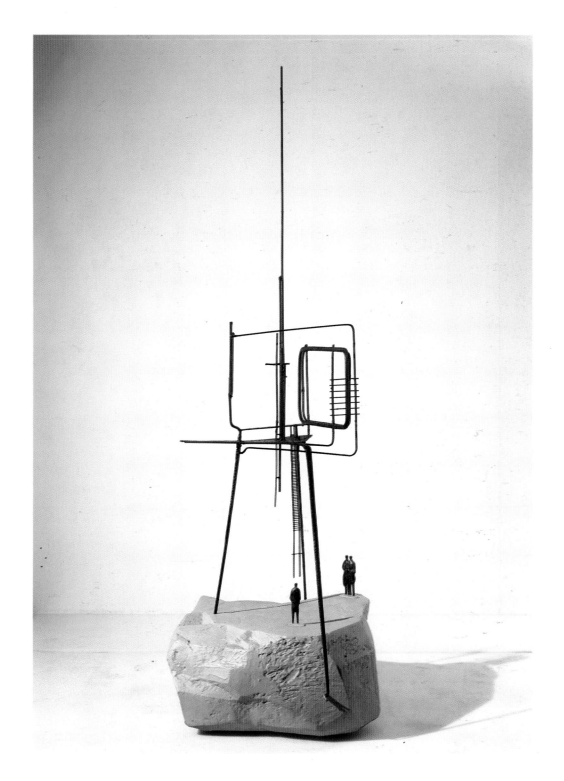

Reg Butler, **Working Model for
'The Unknown Political Prisoner'** 1955-6

Henry Moore and Eight Younger British Sculptors

Henry Moore's sculpture was shown in the British Pavilion at the 1948 Venice Biennale, when he was awarded the International Sculpture Prize, and in 1952 the British Council followed up this success by showing Moore again (this time by just one work placed outside the Pavilion), together with eight other younger British sculptors, Robert Adams, Kenneth Armitage, Reg Butler, Lynn Chadwick, Geoffrey Clarke, Bernard Meadows, Eduardo Paolozzi and William Turnbull, who went on to become leading figures of the next generation. All the sculptors included in this historic exhibition are represented in this room, several of them by the actual works which were shown there (Armitage's 'People in a Wind', Butler's 'Woman', Paolozzi's 'Forms on a Bow' and Turnbull's 'Mobile Stabile', for instance). This exhibition now ranks as one of the landmarks in the history of post-war sculpture and was of particular importance in demonstrating to an international audience that sculpture of great interest was being produced in Britain not just by two or three individuals, but by a substantial group of artists working in a wide variety of styles and techniques.

Herbert Read, in his article in the Biennale catalogue, noted that the younger sculptors had drawn inspiration from Picasso, Calder and Giacometti as well as Moore, and went on to characterise them memorably as follows: 'These new images belong to the iconography of despair, or of defiance . . . Here are images of flight, of ragged claws "scuttling across the floors of silent seas", of excoriated flesh, frustrated sex, the geometry of fear'.

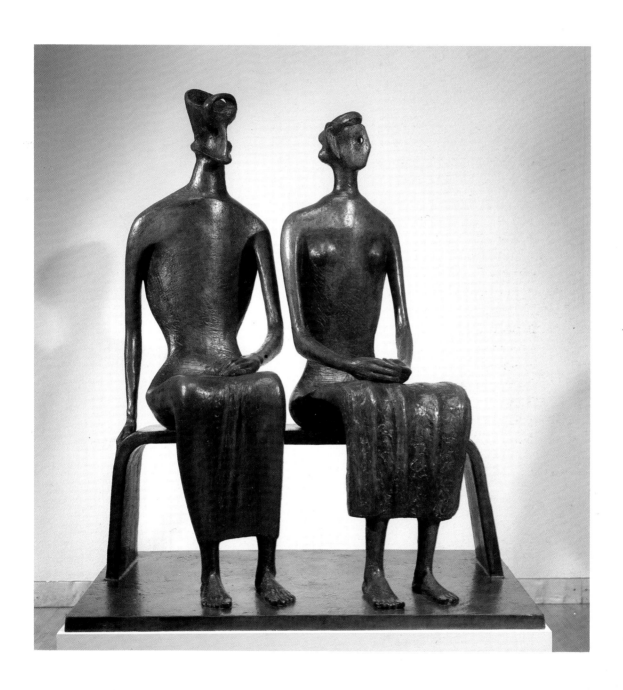

Henry Moore, **King and Queen** 1952-3

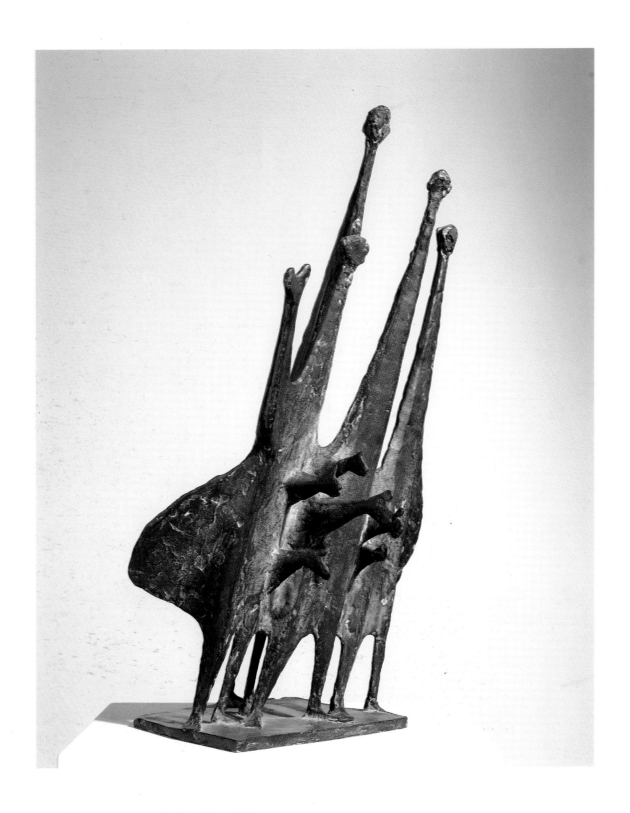

Kenneth Armitage, **People in a Wind** 1950

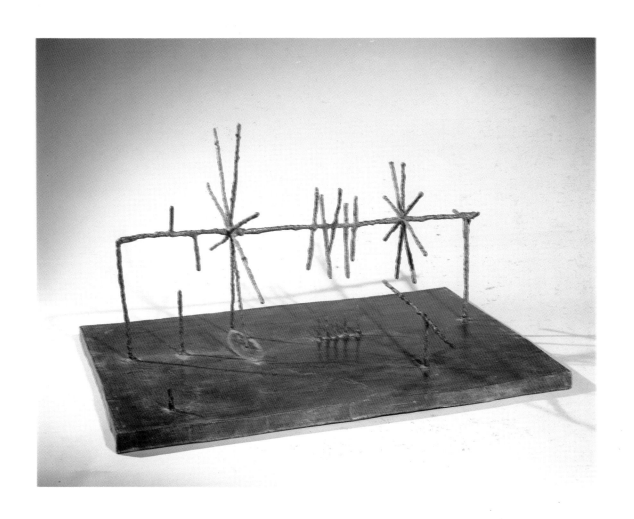

William Turnbull, **Mobile Stabile** 1949

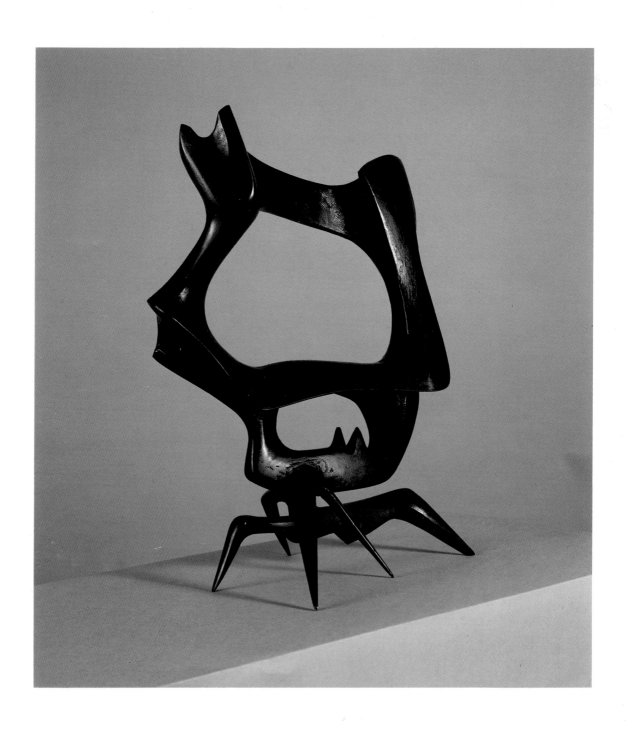

Bernard Meadows, **Black Crab** 1952

Tachism and Cobra

The type of abstract art favoured in the 1930s by the artists of the group Abstraction-Création, with clean-cut, sometimes geometrical forms and clear contrasts of colour, was continued in Paris after the war by Herbin, Vasarely, Gorin and a few others, but most post-war School of Paris abstract painting has been of a looser, more improvisatory kind sometimes known as 'art informel' but usually as tachism (after the French word 'tache', meaning spot or stain). Although the work by some of the artists, such as Poliakoff and Manessier, still has a partly Cubist structure, the majority have adopted freer, more calligraphic styles (for example, Hartung and Soulages) or the use of irregular spots or patches of colour (Riopelle and de Staël), sometimes with a thick, richly textured surface. This development took place quite independently of what was happening in New York but has some affinities with it, except that School of Paris painting has tended to be less radical and more conventional in scale, and to be in the French tradition of 'La belle peinture'.

Tachism, and particularly the interest in rich textures, had considerable influence on Spanish painters such as Tàpies, who built up surfaces like old, battered walls incised with graffiti, and on the Italian artist Burri who incorporated in his paintings materials such as sacking.

Another related European movement of the early post-war years was Cobra, so-named because most of the artists came from the Low Countries (Co = Copenhagen, Br = Brussels, A = Amsterdam). It was founded in Paris in 1948 and only lasted officially until 1951, though some of the artists, such as Jorn and Appel, continued painting in Cobra styles for many years afterwards. Constant's 'Après Nous la Liberté' is a work from the actual Cobra period. In their search for spontaneity and irrational 'uncivilised' forms of expression, the artists turned for inspiration to primitive art, children's art and graffiti, and in many of their paintings grotesque imagery of faces and animals seems to be emerging from a turbulent paint surface.

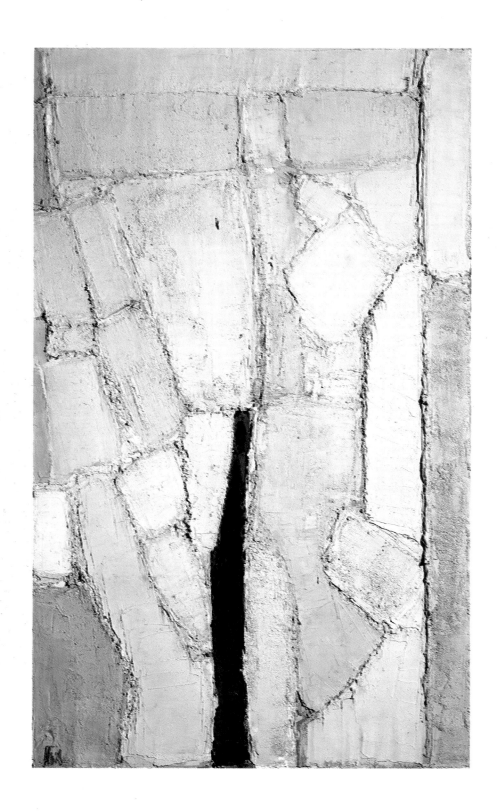

Nicolas de Staël, **Composition 1950** 1950

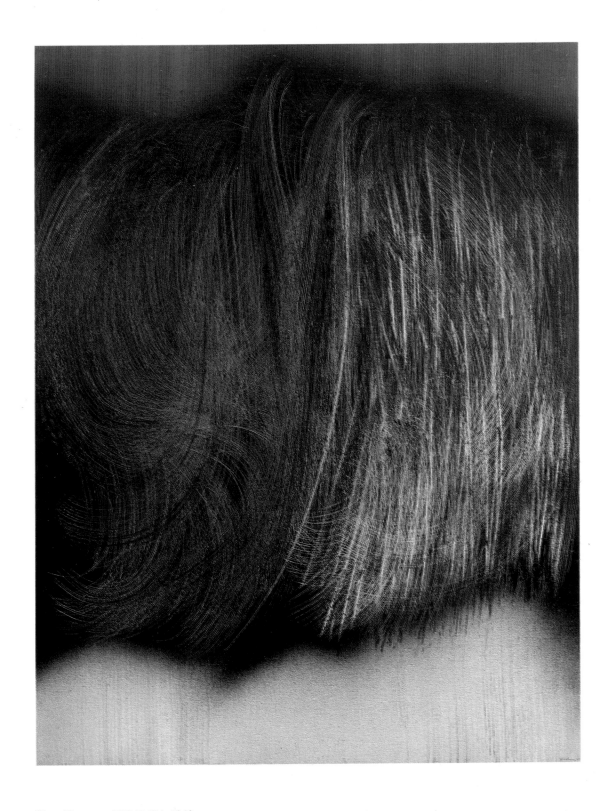

Hans Hartung, **T1963–R6** 1963

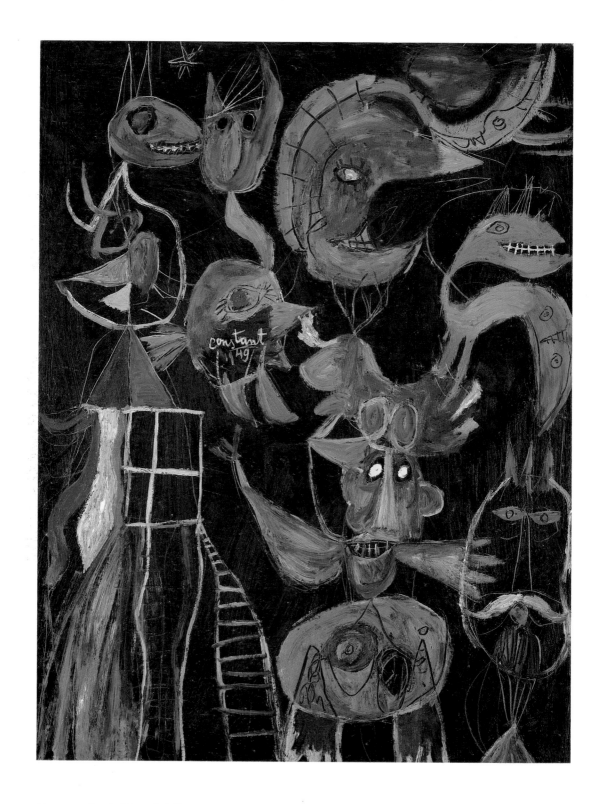

Constant, **Après Nous la Liberté** 1949

Asger Jorn, **Letter to My Son** 1956-7

Rothko

The Rothko room has become one of the noted features of the Tate, and is due to the generosity of the artist himself, who gave one of the paintings in 1968 and the remainder a year later, just a few weeks before his death. They were presented on condition that they would be exhibited in a space of their own.

They all come from the group of paintings which Rothko made in 1958-9 for the Four Seasons Restaurant in the Seagram Building, New York, designed by Mies van der Rohe and Philip Johnson. Rothko's idea was that his paintings were to hang above the heads of the diners. In carrying out this commission, the first he had ever undertaken of this kind, Rothko executed three series of paintings, beginning with works which were very similar to his usual paintings of the time, with horizontal soft-edged rectangular patches of colour hovering in front of a contrasting ground. In the second and third series however – the two series from which the Tate's pictures come – he simplified and adapted his style more and more to meet the needs of a large-scale mural commission, restricting his colours to dark, sombre maroon and black, and adopting the austere and monumental theme of an open rectangle like the after-image of a window. When he had finished, after working on the commission for about eight months, he decided that the paintings were completely out of keeping with such an elegant, fashionable setting; and he returned the money he had been paid and kept the pictures for himself.

It was his wish that his pictures should be objects for contemplation and that they should have a kind of inner drama and majesty. He is on record as stating that he wanted the paintings made for the Four Seasons Restaurant to create a strong mood and a feeling of oppressive spatial enclosure.

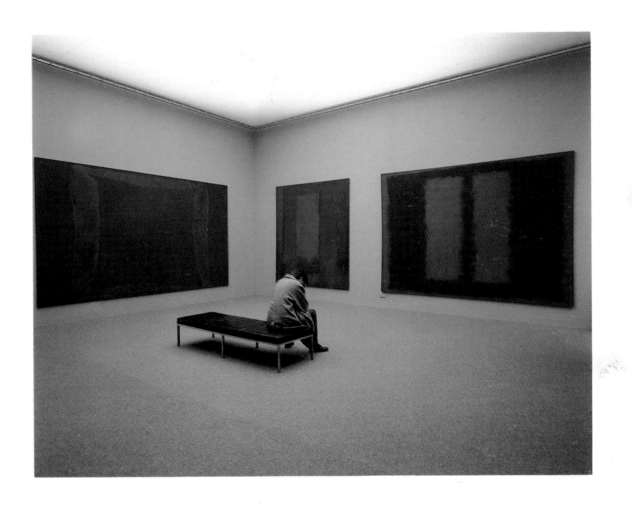

Mark Rothko, general view of Rothko room

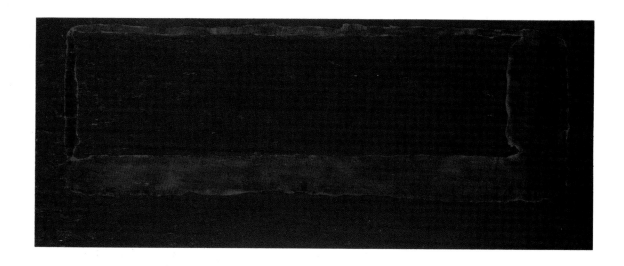

Mark Rothko, **Red on Maroon** 1959

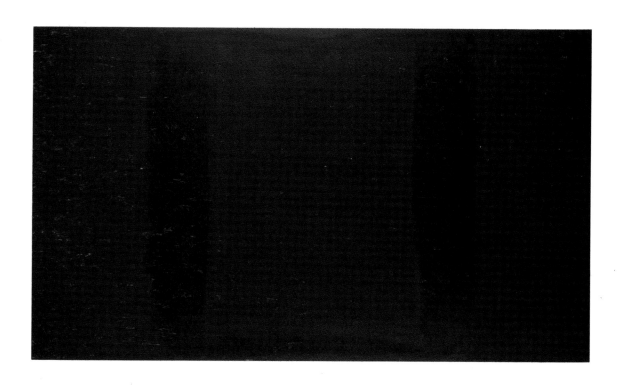

Mark Rothko, **Black on Maroon** 1959

Giacometti

Although Giacometti was already well known before the war, especially for the sculptures which he made while he was a member of the Surrealist movement from 1930-5, his early work is characterised by restless experiment and he only arrived at his fully typical style with its thin elongated figures in 1947. His idiosyncratic, startling and extraordinarily intense post-war sculptures and paintings are among the greatest achievement of the last forty years.

His sculptures made since 1947 are mostly either standing figures or portrait busts. The standing figures are female, as upright, rigid and frontal as idols, with large feet rooted to the base and extremely attenuated bodies. They seem to be almost lost in the space that surrounds them and yet disturbingly alive; images, one could say, of a poignant loneliness. The full-length male figures, on the other hand, are more active, and walk or point. The portrait heads and busts have an alertness and intensity of gaze which confronts the viewer with the sudden impact of an unexpected human presence.

Giacometti made these sculptures very quickly by modelling over slender metal armatures, but then stripping the works down and remaking them obsessively over and over again in an effort to capture effects which were so complex and elusive that he felt they always partly evaded him. Their surfaces are vigorous, rough and craggy.

The paintings he made since the war are usually of single figures seated or standing in a room (his own studio) and like the sculptures were mostly made from the same few models who posed for him day after day, month after month, particularly his wife Annette and his brother Diego. Just as the sculptures have very little volume, so the paintings have little colour and tend to be executed in almost monochrome ochres and greys. Although done from models posed quite close to him, the figures have an extraordinary feeling of remoteness and untouchability, of being isolated in space, vibrating in their stillness.

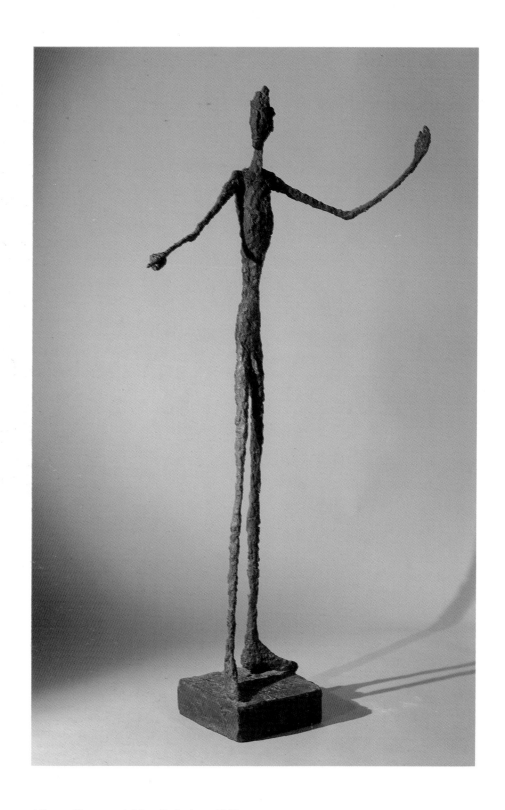

Alberto Giacometti, **Man Pointing** 1947

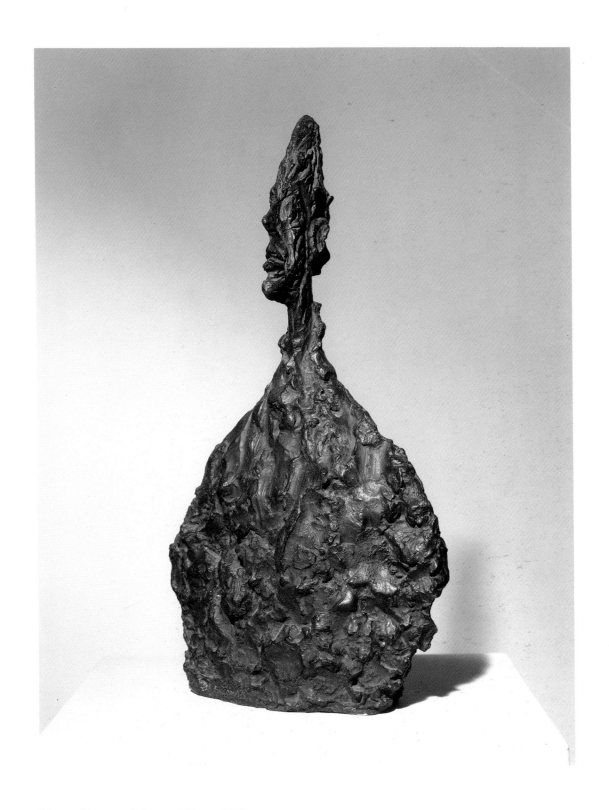

Alberto Giacometti, **Bust of Diego** 1955

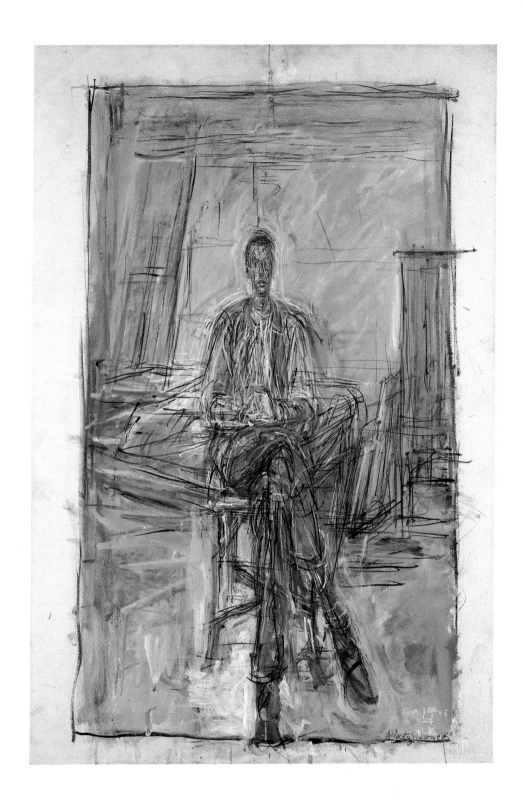

Alberto Giacometti, **Seated Man** 1949

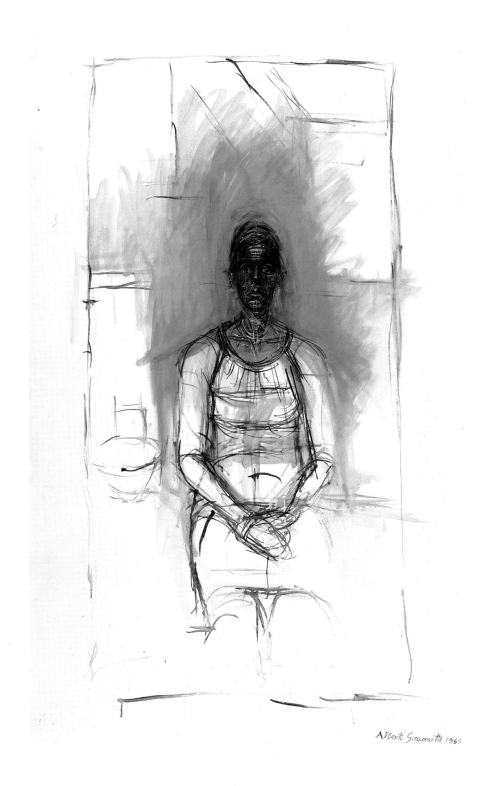

Alberto Giacometti, **Caroline** 1965

Dubuffet

Jean Dubuffet is widely regarded as the most inventive and influential painter to have been produced by the School of Paris since the war. Doubting the value of art and culture, he admired and collected naive graffiti and the art of primitives and the insane (what he called 'art brut'), and his works tend to combine lively, grotesque imagery with an extraordinary painterly sophistication. His output falls into a number of series centred round particular themes.

The portrait of the poet Henri Michaux is one of a series of imaginary portraits of his writer and artist friends made in 1946-7 which are among his most important early works, and the flattened figure seems to be gouged out of the dense, wall-like paint in a deliberately crude or primitive style. To make 'The Busy Life' of 1953 he smeared a smooth light-coloured paste over layers already thickly painted and still fresh, in such a way that the various colours underneath showed through in places; and then hastily traced rudimentary figures with a knife into the paste. The 'Texturology' series of 1957-8, on the other hand, was made by shaking a brush over the paintings spread on the floor, covering them with a spray of tiny droplets, and then scattering sand over the paintings, and so on. This created an effect like soil, but alive and sparkling, and even evoking galaxies and nebulae. Whereas the 'Texturology' paintings were almost abstract and arose out of the fact that he was then living in the countryside, 'Spinning Round' 1961 is one of a number of works produced by the shock of his first long visit to Paris for seven years: the animation of the streets teeming with people, the pavements, the shopfronts.

From 1962-74 he worked on an extensive series known as 'Hourloupe' (a made-up word) characterised by flat interlocking shapes and striated colouring, usually red, white and blue. The Tate has two paintings and a 'praticable' from this series, 'praticable' being a word which means a piece of stage scenery which is not painted but has a real existence; in the case of Dubuffet's works, a painting with irregular edges mounted on a metal stand. 'The Ups and Downs', a post 'Hourloupe' work, is an assemblage of no less than thirty-five separate paintings on paper, cut out and overlapping, some abstract and some with Dubuffet's characteristic hobgoblin-like figures.

Jean Dubuffet, **Monsieur Plume with Creases
in his Trousers (Portrait of Henri Michaux)** 1947

Jean Dubuffet, **The Busy Life** 1953

Jean Dubuffet, **Nimble Free Hand to the Rescue** 1964

Jean Dubuffet, **The Ups and Downs** 1977

Nicholson, Pasmore and British Abstract Art

The only British centre for abstract art in the years immediately after the war was St Ives in Cornwall, where Ben Nicholson and Barbara Hepworth had settled on the outbreak of war, followed shortly afterwards by Naum Gabo (who moved on to the United States in 1946). Though continuing to some extent the abstract tradition of the 1930s, they were all influenced in some way or other by the beauty of the Cornish landscape: Hepworth made sculptures inspired by caves, monoliths and wave forms, while Nicholson largely abandoned pure non-figuration to make small stylised landscapes of St Ives and its environs, as well as post-Cubist still life compositions. Their presence at St Ives attracted various younger artists such as Lanyon, Wells, Barns-Graham, Heron, Frost and Mitchell.

A second wave began in 1948 with the conversion of Victor Pasmore to abstraction. One of the founders of the Euston Road School and widely admired for his extremely lyrical landscape and figure studies, Pasmore had become more and more interested in Cézanne, Seurat and Post-Impressionism, and had begun to experiment along these lines until he reached what he felt was an impasse. His decision in 1948 to start again with abstract art, using a basic vocabulary of forms such as the circle, square and spiral, was a turning point in post-war British art; and he was followed soon afterwards by a small group of artists who were pupils or friends of his such as Kenneth Martin, Adrian Heath, Terry Frost and Anthony Hill. Contacts were established with Ben Nicholson and the others living in Cornwall, though the two groups remained fairly distinct. By 1951 Pasmore had become convinced that the further development of painting lay in the relief, and for some years afterwards gave up painting to make relief constructions. Anthony Hill and Mary Martin also turned to making reliefs, while Kenneth Martin started to make sculpture.

Whereas Pasmore was essentially an intuitive artist, Anthony Hill and the Martins adopted a more systematic approach and based their work on numerical progressions and the like, so that their work belongs to the tradition of pure Constructivist art. Kenneth Martin's late 'Chance and Order' paintings were made by following a set of rules of his own devising, which also introduced an element of chance.

Ben Nicholson, **August 56 (Val d'Orcia)** 1956

Victor Pasmore, **Square Motif,
Blue and Gold: The Eclipse** 1950

Anthony Hill, **Relief Construction** 1960-2

Kenneth Martin, **Chance, Order,
Change 12 (Four Colours)** 1980

British Artists and Abstract Expressionism

The first British painter – and perhaps the first of all European artists – to realise the vitality and significance of American Abstract Expressionism was Alan Davie, who saw the Pollocks from Peggy Guggenheim's collection in Venice in 1948 and was inspired by them to begin painting on a much larger scale, in an improvisatory way, with a vigorous, aggressive handling of paint and images suggesting movement and primitive, magical rituals.

In the course of the 1950s more and more British artists became aware of the innovations of the New York School through such exhibitions as 'Modern Art from the United States' (from the collections of the Museum of Modern Art, New York) at the Tate in 1956, and other exhibitions at the ICA and in dealers' galleries. In addition, various British painters visited New York and met leading artists of the New York School (Scott in 1953, Davie in 1956, Lanyon in 1957 and so on); Patrick Heron, while London correspondent to *Arts* (New York) from 1955-8, was one of the first British critics to write enthusiastically about the new American painting.

The influence of Abstract Expressionism had a particularly invigorating effect on some of the younger artists associated with St Ives and West Cornwall, such as Lanyon, Heron, Frost, Hilton and Wynter, who tended to begin working on a larger scale, with looser brushwork and a greater painterly freedom.

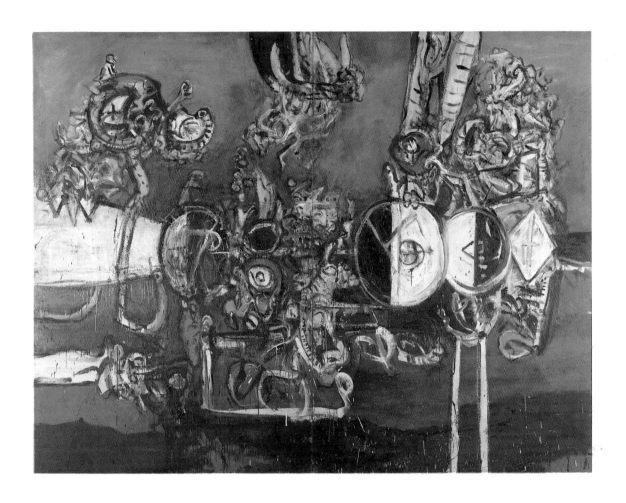

Alan Davie, **Sacrifice** 1956

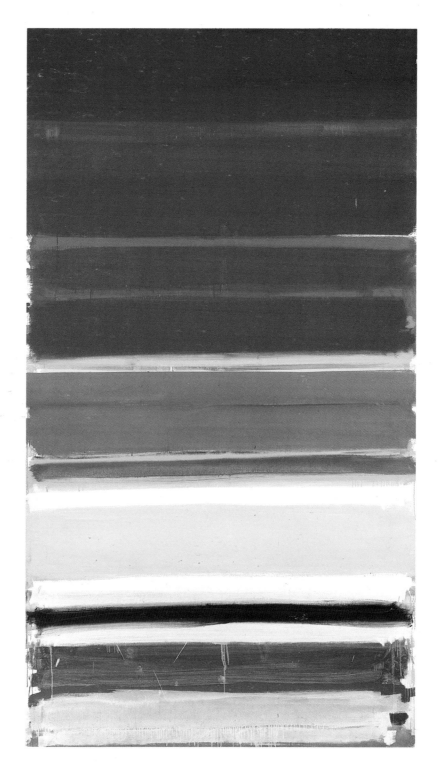

Patrick Heron, **Horizontal Stripe Painting:**
November 1957 – January 1958 1957–8

Peter Lanyon, **The Wreck** 1963

Roger Hilton, **Oi yoi yoi** 1963

Caro and Colour-Field Painting

The type of Abstract Expressionist painting created by Barnett Newman, with large uniform expanses of saturated colour, led in the late 1950s and 1960s to the development of what is often known as colour-field painting. Among its other pioneers were Morris Louis and Kenneth Noland, who took over from Helen Frankenthaler the technique of staining very liquid acrylic paint into absorbent cotton duck. Louis's waterfall-like 'veil' paintings were apparently made by pouring layer upon layer of thin paint onto an unstretched canvas and controlling its spread and flow. Noland, on the other hand, used regular schematic compositions such as concentric circles, chevrons or series of parallel horizontal stripes as the basis for a wide range of colour effects.

This kind of painting, usually less dramatic and more hedonistic than first-generation Abstract Expressionism, was also the inspiration for the British artists of the Situation group, Bernard and Harold Cohen, Richard Smith, Turnbull, Hoyland, Denny and others, who exhibited together in 1960, 1961 and 1962. Richard Smith had links with Pop Art and combined a staining technique with allusions to modern packaging (including the use of three-dimensional shaped canvases), but the works by the others were completely abstract; unlike the Abstract Expressionist painters working in or near St Ives, they avoided all traces of landscape.

It was the example of Noland's paintings, as well as the work of the sculptor David Smith, that brought about a complete change of style in Caro's sculpture in 1960 and induced him to start making totally abstract welded metal sculptures of an open, spatial kind which stood directly on the floor, without any bases, and which were painted in brilliant colours. These innovations were in turn a source of inspiration to various younger sculptors who were, or had been, pupils of his in the sculpture department at St Martin's School of Art, such as Phillip King, Tim Scott and William Tucker, who began to work not only with metal but with fibreglass and plastic, which enabled them to create some strange, exotic forms of a kind that had never been seen in sculpture before. The strong, gay colours of their early works are related to colour painting of the time.

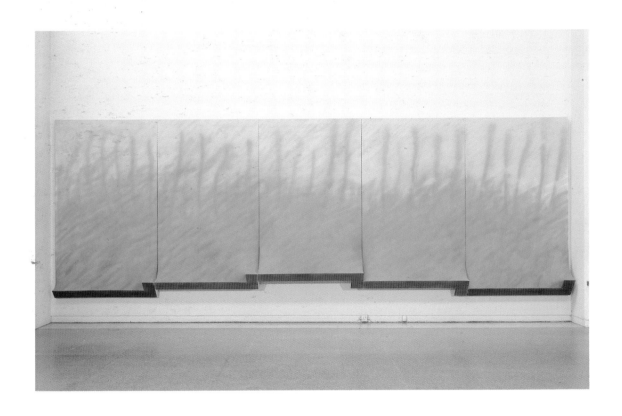

Richard Smith, **Riverfall** 1969

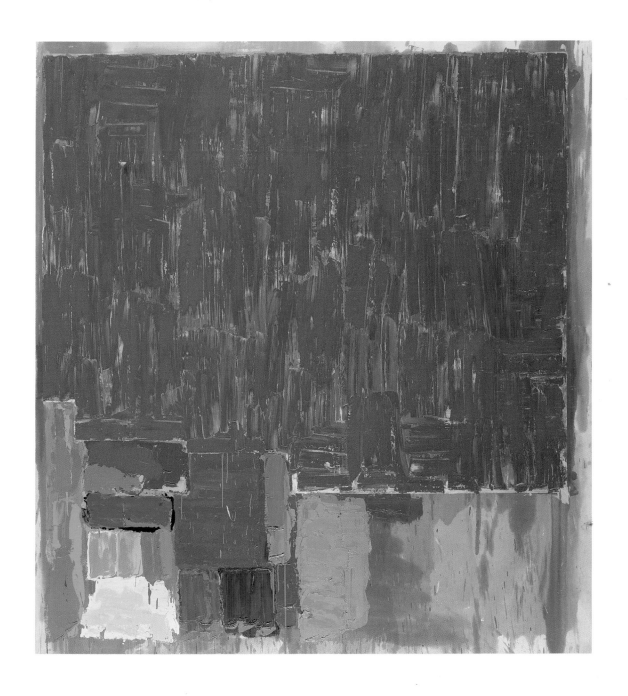

John Hoyland, **Saracen** 1977

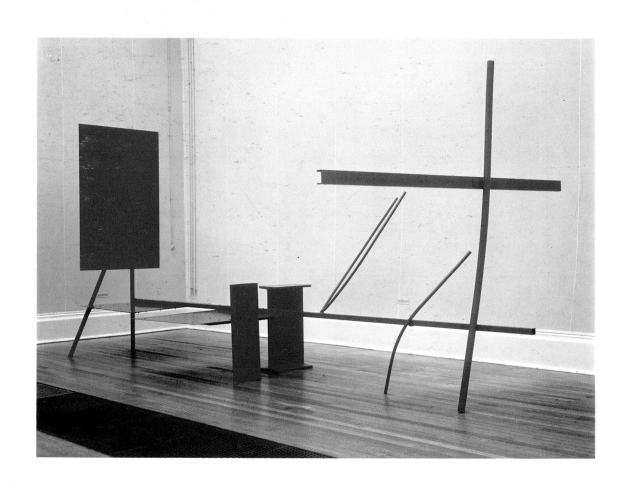

Anthony Caro, **Early One Morning** 1962

Phillip King, **Tra-La-La** 1963

Op and Kinetic

The term 'Op Art' (short for optical art) was first used in 1964 to denote a certain type of abstract art, usually of Constructivist origin, which explored optical phenomena such as the interaction of colours, after-images, effects of dazzle, moiré patterns and perceptual movement, often in a systematic manner. Its most influential pioneers were Josef Albers, who began in 1949 to paint the series of pictures called 'Homage to the Square' in which he used a standardised compositional schema of either two or three squares within a square to explore a wide range of colour effects, advancing and receding colours, expanding and contracting colours, and so on; and Victor Vasarely, with his shifting colour planes or dazzling juxtapositions of black and white. Op paintings are mostly flat and hard edged, and often geometrical and systematic in structure.

Although some of these works depend for their effect on the movement of the spectator in front of them to produce an interaction of superimposed patterns (as in the case of most works by Soto) or so that the colours and patterns change as one moves past them from one side to the other (Cruz-Diez), they differ from kinetic art in that kinetic works themselves move, either by means of an electric motor or through the intervention of some other outside force such as air currents.

The first true kinetic sculpture seems to have been Gabo's 'Kinetic Sculpture (Standing Wave)' made as early as 1919-20 – which the Tate now owns – but most of the pioneering kinetic works were isolated one-off experiments, and the only artist of the inter-war years who took kinetic effects as his principal theme was Alexander Calder, who began making mobiles in the early 1930s. Calder's works, which usually consist of painted cut-out metal shapes suspended from rods and activated by air currents, have been an inspiration to many of the later kinetic artists.

Since the mid-1950s a number of artists have produced kinetic works of various kinds, incorporating a wide variety of forms, materials and types of movement. Some kinetic works perform a standard sequence of movements which is precisely repeated, over and over again; others are more or less random and unpredictable. They range from severely Constructivist works to pieces which have an exceptional toy-like fantasy and humour.

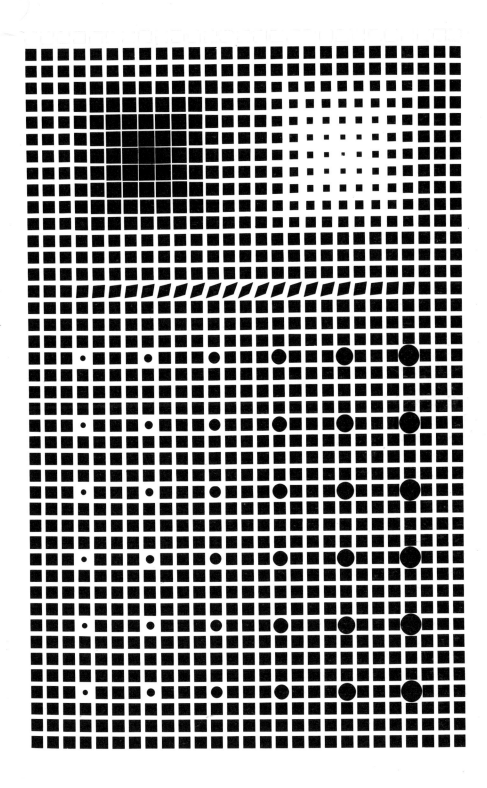

Victor Vasarely, **Supernovae** 1959–61

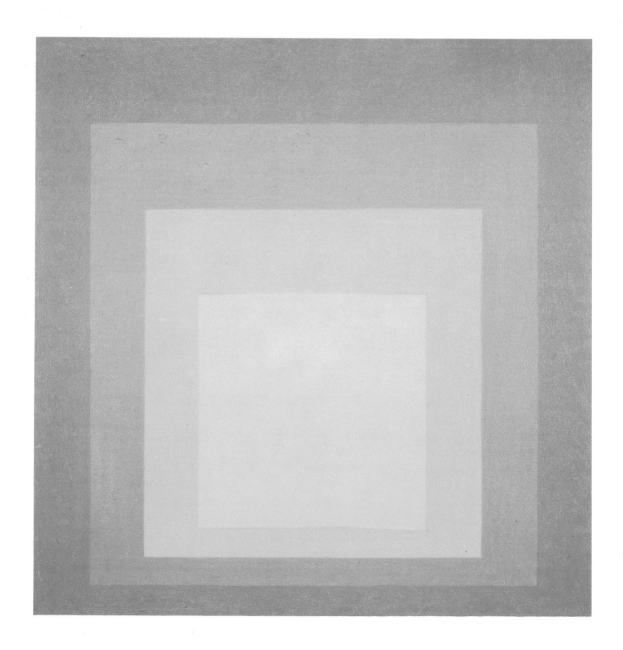

Josef Albers, **Study for Homage to
the Square: Departing in Yellow** 1964

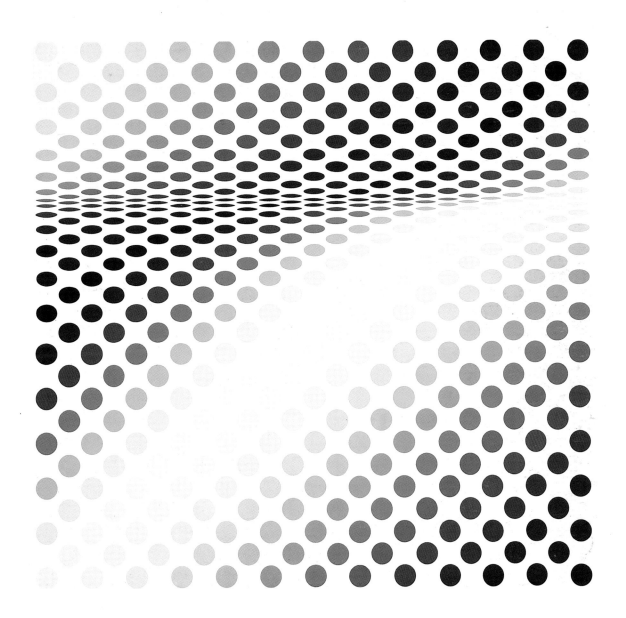

Bridget Riley, **Hesitate** 1964

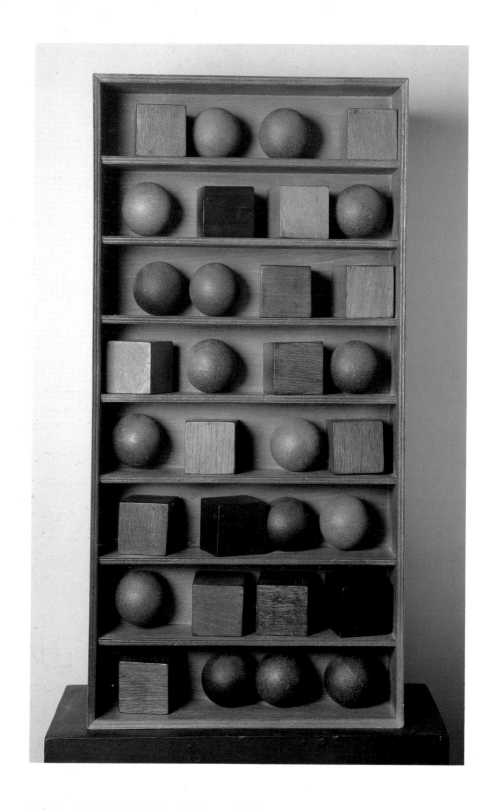

Pol Bury, **16 Balls, 16 Cubes in 8 Rows** 1966

Fontana, Klein and Nouveau Réalisme

The two most radical European abstract artists of the post-war period have been the Italian Lucio Fontana and the Frenchman Yves Klein. Fontana, over a generation the older of the two, founded the avant-garde Spazialismo movement in Italy in 1948 and the following year began to make pictures by punching the canvas surface with holes and, later, by making rhythmical sweeping cuts with a razor blade. Klein is known above all for the completely monochrome pictures which he made from the early 1950s onwards, at first sometimes green, white, yellow or red but from 1957 mainly a very distinctive blue, a deep sensuous cobalt, which he named International Klein Blue (IKB), and which for him symbolised infinite space.

Exhibitions of Klein's works in Italy and Germany prompted the young Italian painter Piero Manzoni, sometimes regarded as his Italian counterpart, to begin making series of completely white pictures known as 'Achromes', with surfaces of a variety of textures, and also led to the formation in Düsseldorf of the Zero group led by Piene, Mack and Uecker (whose sister he married). The Dutch artist Schoonhoven was another of those who collaborated in Zero.

Through Klein's friendships with two artists working in his home town of Nice, Arman and Martial Raysse, and his meeting in Paris with Tinguely and Hains, the group Nouveau Réalisme (New Realism) was founded in 1960 by the critic Pierre Restany. The original members included Klein, Tinguely, Raysse, Arman, Hains and Spoerri, who were afterwards joined by César, Niki de Saint-Phalle and Christo. Although the group had come together around the activities of Klein, the main preoccupation of the others was to revitalize the School of Paris through the use of commercial images and consumer goods drawn from the contemporary industrialized environment (and therefore had something in common with the aims of Pop Art). Thus Arman made 'Accumulations' of objects; Tinguely created wildly fantastic kinetic constructions out of scrap-metal parts; Spoerri fixed the plates and other objects used in a meal in the exact positions in which they happened to be left at the end of the meal; Christo began to wrap cans, chairs and so on; and César to compress car bodies in industrial machines made for this purpose.

Klein and Manzoni, who both died young, also made some works towards the end of their lives which helped lead the way to Conceptual Art.

Yves Klein, **IKB 79** 1959

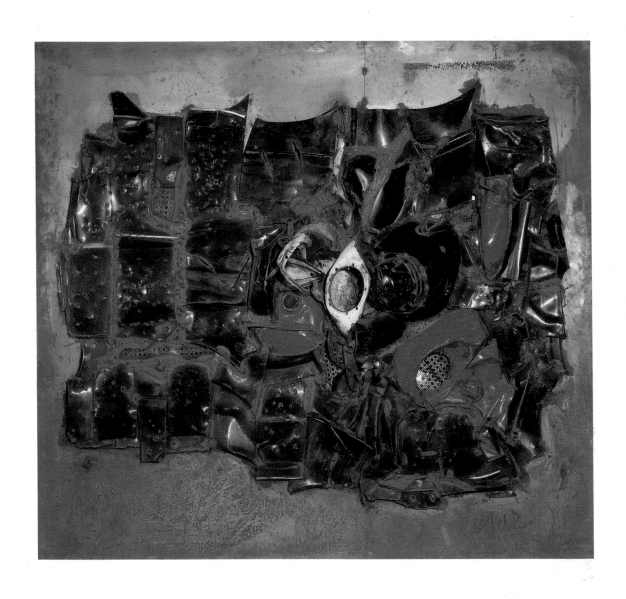

César, **Portrait of Patrick Waldberg** 1961–2

Lucio Fontana, **Spatial Concept** 1958

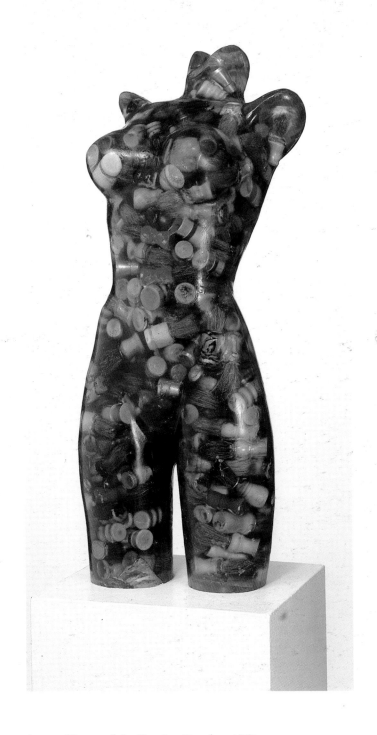

Arman, **Venus of the Shaving Brushes** 1969

Francis Bacon and Figurative Painting in Britain

Although Francis Bacon began to paint as long ago as 1929, he was a slow starter, and it was only at the end of the war that he developed his characteristic figure style and began to be recognised as one of the most powerful and original artists of recent years. A figurative painter during a period dominated by abstract art, he works mainly from photographs of various kinds, but his paintings have a sumptuousness and grandeur akin to Old Masters like Titian and Velazquez. The drama and anguish in his works is sometimes produced partly by bizarre, shocking combinations of imagery taken from completely different types of photographs, and sometimes simply through the expressive violence of his distortions and his handling of paint. His favourite theme is a single figure, usually male, seated or standing in a claustrophobic, windowless interior.

Lucian Freud, a close friend of Bacon's, expresses a similar mood of isolation and tension but usually with a sharp-focussed, unflinching realism, while Michael Andrews, in his early works such as 'The Deerpark', adapts Bacon's practice of combining images from a number of different photographs. Other British figure painters of a sombre, expressive kind whose work has some affinity to Bacon's include Frank Auerbach and Leon Kossoff, both of whom work obsessively, painting and repainting with a thick, vigorous application of paint, until they feel that they have achieved the rawness, individuality and highly charged end result they are seeking.

The Australian painter Sidney Nolan was one of the first artists to give Australian art a distinctive, national identity, but has lived mainly in England since 1955. His paintings of such themes as the bandit Ned Kelly, in his protective helmet, and Mrs Fraser and the convict give episodes from the early pioneering history of Australia the epic quality of myths.

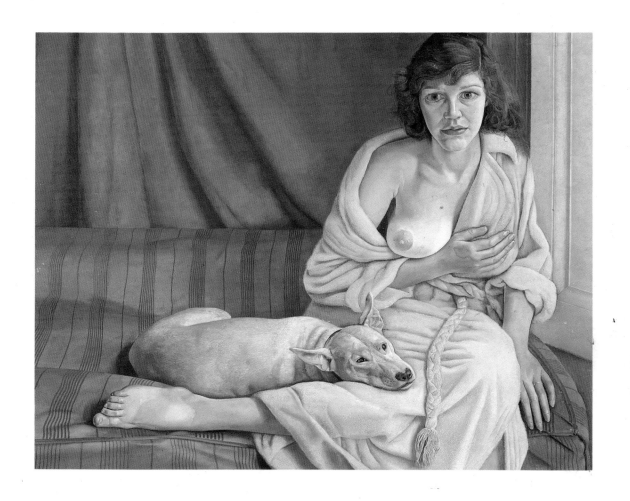

Lucian Freud, **Girl with a White Dog** 1950-1

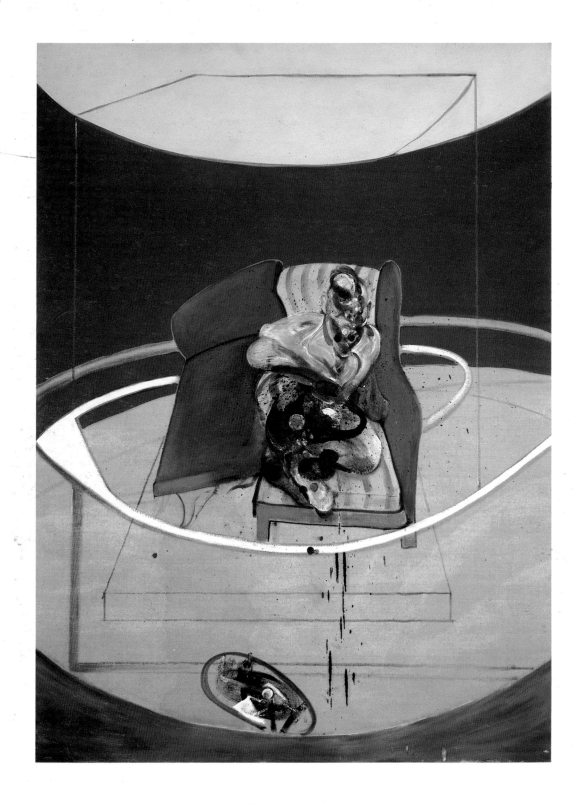

Francis Bacon, **Study for Portrait on Folding Bed** 1963

Frank Auerbach, **The Sitting Room** 1964

Minimal and Conceptual Art

The first steps in the reaction against the gestural, expressionist and improvisatory kinds of Abstract Expressionism were taken by several of the Abstract Expressionists themselves, particularly Barnett Newman with his large uniform fields of colour, and Ad Reinhardt with his near-black canvases and symmetrical, cruciform compositions. Another pioneer was Ellsworth Kelly who began in 1954 to make paintings in black and white, or one colour and white, with simple hard-edge divisions of the picture surface.

Frank Stella based his eight aluminium paintings of 1960, including 'Six Mile Bottom', on bands of uniform width which were made to jog to one side and then turn again to resume their original direction; and which therefore generated irregular-shaped formats with symmetrical notches at the corners or halfway up the sides, or with a hole in the centre. Not only were these pictures executed in industrial paint applied as uniformly as possible, but they were made according to a set of rules which the artist had devised for himself. The series of eight brick sculptures by Carl Andre known as 'Equivalents', first created in 1966, was made in a similar logical spirit, as each work consisted of 120 bricks stacked in two layers to form a rectangular mound, but put together in different combinations so that each was a different shape.

This concern with simple, basic forms such as cubes or rectangular slabs, and uniform surfaces often of an industrial character, became characteristic of much of the sculpture produced from about 1964 onwards. Robert Morris, Don Judd and Sol LeWitt who were, with Andre, leading representatives of this Minimal tendency, all started to have their pieces fabricated from their designs by industrial craftsmen. The emphasis therefore began to shift more and more to the idea behind the work.

LeWitt himself, with his wall drawings which existed to begin with simply as a set of instructions, was one of those who opened the way for Conceptual Art and what has been called 'the dematerialisation of the art object'. Developing partly in reaction against the geometry and sheer bulk of much Minimal art and partly as a reaction against the demands of the art market, many artists started in the second half of the 1960s to make works of a temporary character, utilising different types of process and system, inscribing imaginary geometric patterns on the landscape, and so on. Sometimes nothing survives from these, sometimes some kind of documentation was created.

Ellsworth Kelly, **Broadway** 1958

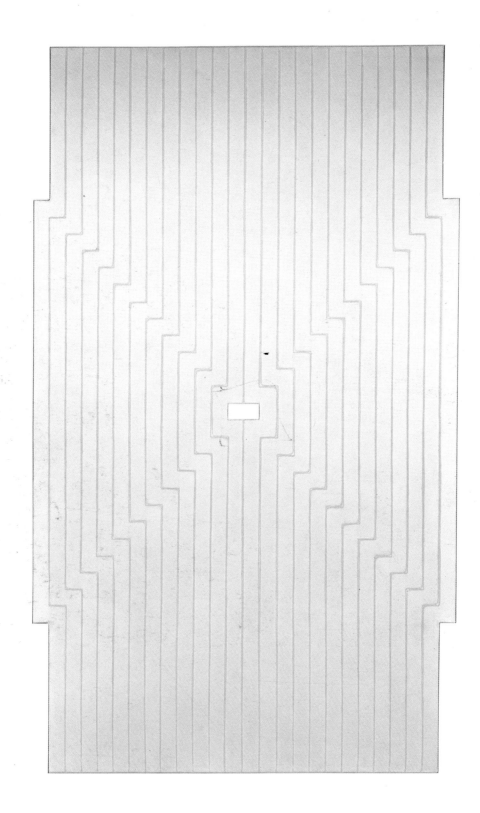

Frank Stella, **Six Mile Bottom** 1960

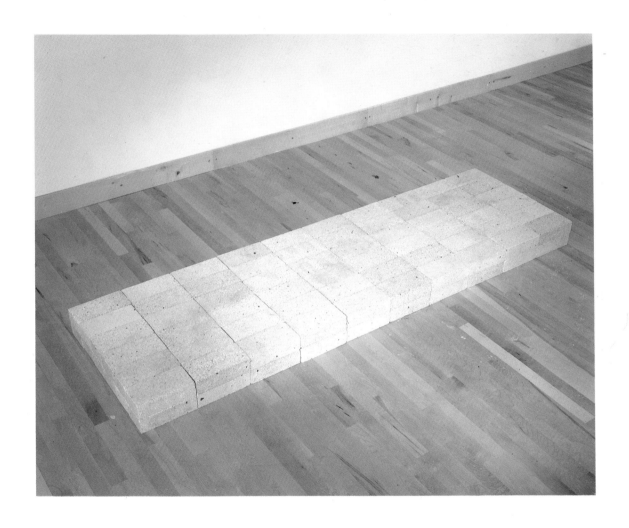

Carl Andre, **Equivalent VIII** 1966

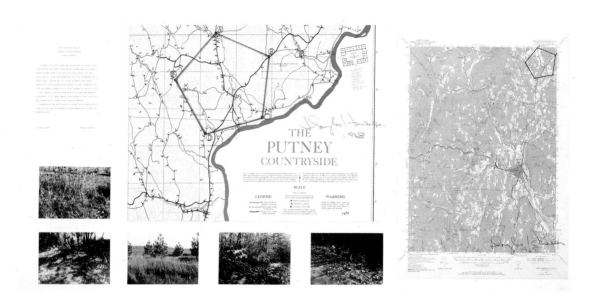

Douglas Huebler, **Site Sculpture Project,**
Windham College Pentagon, Putney, Vermont 1968

British Pop Art

What is known as Pop Art originated in Britain in the mid-1950s, and also independently in the United States a little later, as a response to the mass-circulation arts – photo-advertising, car styling, Hollywood films and science fiction – which were flourishing in an environment of increasing prosperity and commercialization. This visual material also had the attraction that it was non-elitist, colourful, garish and often sexy.

The first centre from which the movement sprang in Britain was the meetings of the Independents' Group at the Institute of Contemporary Arts (then in Dover Street), where the main theme for discussion was popular culture and the new sources of imagery which it provided. Eduardo Paolozzi and Richard Hamilton were among the most active participants, and in 1956 Hamilton made a collage which is regarded as the first work of Pop Art. Meantime Peter Blake, at the Royal College of Art, was developing a form of art which combined folk art styles such as fairground painting with imagery drawn both from Victoriana and from his idols among his contemporaries, such as pop singers, pin-ups and film stars. A second wave of Pop works, which rapidly attracted great attention and helped to establish the movement in the public mind, was produced by a group of artists who had studied together at the Royal College of Art about 1959-62, and who included Derek Boshier, Patrick Caulfield, David Hockney, R. B. Kitaj, Allen Jones and Peter Phillips. (Although Kitaj was not strictly speaking a Pop artist, in that his paintings were based not on pop imagery but on an erudite iconography inspired by Central European political events and the like, his technique of multiple, associative imagery was one of the typical components of the British Pop Art style).

Apart from Patrick Caulfield, who from the beginning showed a preference for bold, simple designs and uniform expanses of colour, much of the work by the British Pop artists was fairly complex and intricate in composition. Hamilton, a highly sophisticated artist, explored the interplay of styles, while the work of Hockney, Jones and Phillips has a youthful freshness and exuberance, and sometimes a markedly autobiographical character.

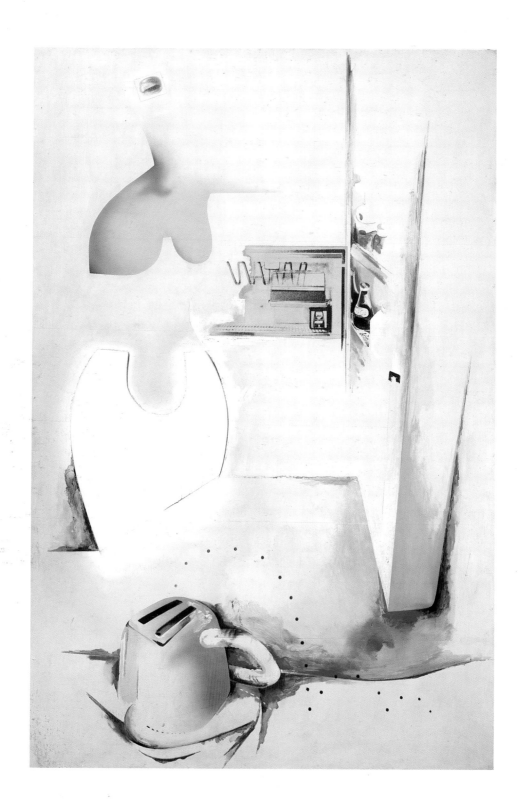

Richard Hamilton, **$he** 1958-61

R.B. Kitaj, **Isaac Babel Riding with Budyonny** 1962

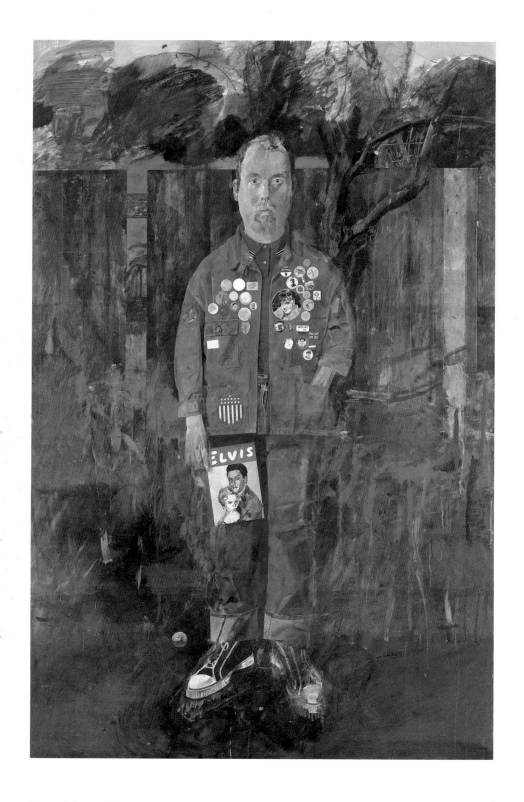

Peter Blake, **Self Portrait with Badges** 1961

Allen Jones, **The Battle of Hastings** 1961-2

British Post-Pop

By the second half of the 1960s most of the artists who founded the British Pop Art movement had begun to move away from pop imagery and to work in more straightforward, traditional styles. David Hockney, for instance, painted a series of double portraits of friends such as the fashion designers Ossie Clark and Celia Birtwell (with their cat Percy), as well as paintings of the elegant villas and swimming pools in Los Angeles where he was then spending much of his time. Kitaj likewise turned away from compositions which combined several different types of images.

Peter Blake lived from 1967-79 at Wellow near Bath, where he began to take a keen interest in the myths of country life. With several other artists living in the neighbourhood who shared his interest in a romantic, poetic approach to nature, such as David Inshaw and Graham Ovenden, he founded in 1975 the group known as the Brotherhood of Ruralists, in an attempt to revive the spirit and technique of the Pre-Raphaelites. Blake's 'The Meeting' or 'Have a Nice Day, Mr. Hockney' of 1981-3 depicts Blake himself (the bearded figure on the left) and Howard Hodgkin greeting David Hockney in a Los Angeles setting; the composition is an updating of the famous painting by Courbet 'Bonjour Monsieur Courbet'.

Hodgkin, sometimes wrongly classified as a Pop artist, has based most of his paintings on daily life encounters with friends, such as recollections of dinner parties, but treated in a manner that has tended to become nearly abstract, with rich Matisse-like colours and overlapping colour planes. Neither Anthony Green nor Tom Phillips played any part in the Pop movement, but their work, or some of it, has some affinity with it of mood and character. All Green's paintings since 1961 have been based on his own family life, in scenes depicted in great circumstantial detail and with vividness and humour. In the central panel of the painting named after him, Casimir Dupont, Green's maternal grandfather, who was born in France, is seen listening to the news on the radio of the Fall of France; he is surrounded by other scenes from his life. Tom Phillips's 'Benches' was painted from picture postcards of park benches which, sometimes with people and sometimes not, suggested to him the transience of human existence. The colour stripes comprise a catalogue of the colours he used in painting it.

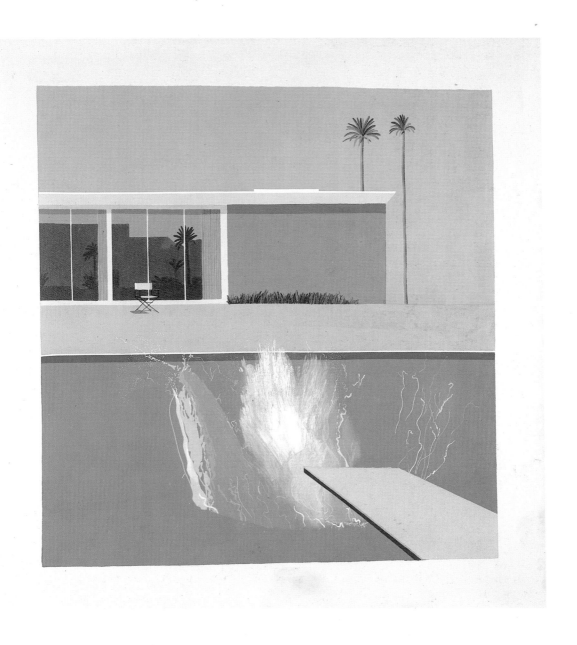

David Hockney, **A Bigger Splash** 1967

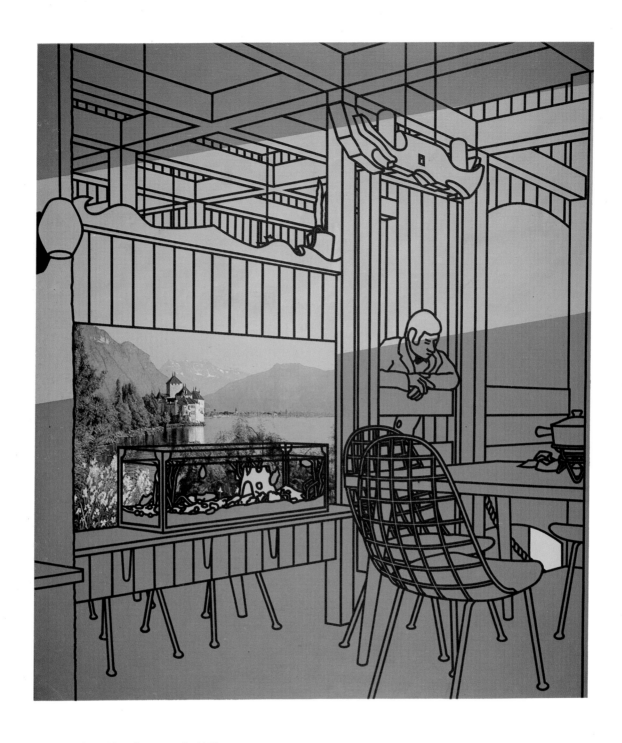

Patrick Caulfield, **After Lunch** 1975

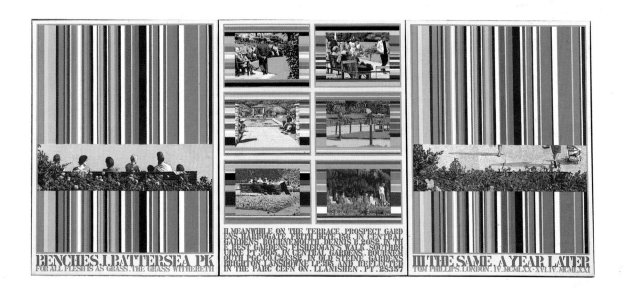

Tom Phillips, **Benches** 1970-1

Howard Hodgkin, **Dinner at Smith Square** 1975-9

American Pop Art

Pop Art did not become a clear-cut movement in the United States until about 1962 and arose independently of what had been happening in Britain. The way for it was however prepared in the second half of the 1950s by the work of Robert Rauschenberg, Jasper Johns and Larry Rivers and by the current interest in Happenings and Assemblage. In his works of the 'fifties, Rauschenberg, for instance, began to incorporate a wide variety of junk collage materials and sometimes real objects such as chairs or stuffed birds, which he fused with Abstract Expressionist type free brushwork. Johns made pictures based on simple emblematic images such as targets or the American flag, but treated with an extraordinary painterly richness. Rauschenberg's 'Almanac' of 1962 is one of his earliest paintings incorporating silkscreen images of various kinds, most of them from photographs he had taken himself and related by free, poetic association, while Johns's 'Zero through Nine' is based on the numbers from 0 to 9 superimposed. (The artist closest to Rauschenberg and Johns in his field of interests was Jim Dine).

The work of Rauschenberg, Johns and Dine is more delicate and complex than that of the full-blooded Pop artists such as Claes Oldenburg, Andy Warhol, Roy Lichtenstein and James Rosenquist who were the central figures of the American movement and who shared a predilection for bold, poster-like images. Oldenburg has taken as his theme the transformation of commonplace objects, first by making painted plaster works based on items of food and cheap clothing, and later objects such as electric plugs, typewriters and shovels which astonish by their dramatic changes of scale or of material, from hard to soft, or soft to hard. The changes, often in the nature of parodies, can be humorous, whimsical and even erotic. Rosenquist worked from 1958-60 as a sign painter, painting the enormous billboards in Times Square and elsewhere in New York; his paintings usually include bizarre juxtapositions of fragments of immense images derived mainly from advertisements. Warhol has used silkscreen for the production of series of paintings of subjects such as 'Campbell's Soup Cans' or portraits of film stars, like the tragic Marilyn Monroe, sometimes with rows of repeated images. On the other hand, Lichtenstein, in a painting like 'Whaam!', takes an image from a comic strip as his starting point, but transforms it not only by the change of scale but by a powerful sense of design and a cool irony.

Robert Rauschenberg, **Almanac** 1962

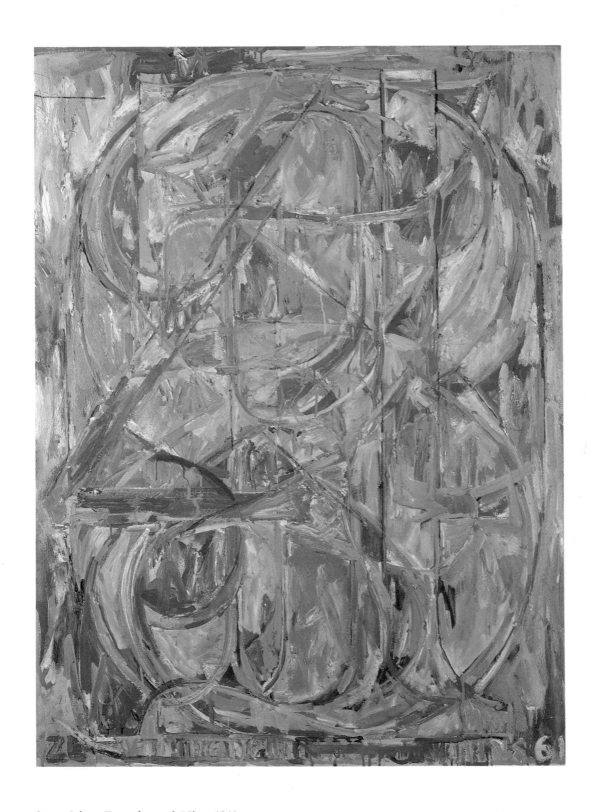

Jasper Johns, **Zero through Nine** 1961

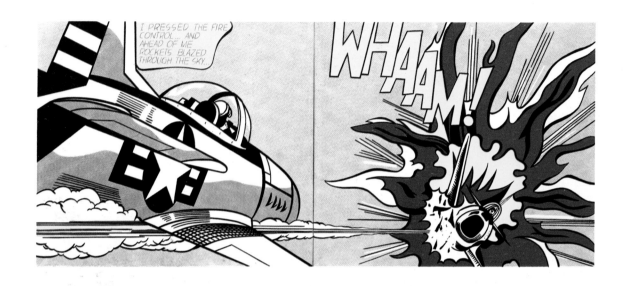

Roy Lichtenstein, **Whaam!** 1963

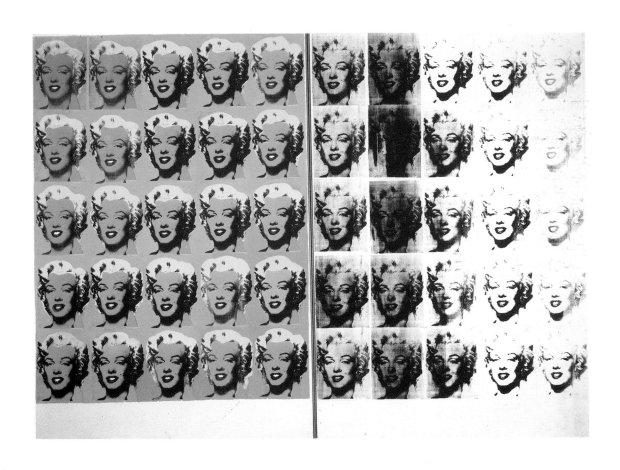

Andy Warhol, **Marilyn Diptych** 1962

Art as Photography

Many artists, such as Rodchenko, Moholy-Nagy, Man Ray and Paul Nash, have taken very fine photographs, but it was only in the 1960s and '70s that a number of painters and sculptors began to make systematic use of photography in connection with their art, and sometimes to adopt it as their sole medium. In some cases these artists first became interested in photography as a means of recording Happenings and installations and other art works of an ephemeral nature for which there would otherwise be no permanent record. Douglas Huebler and Dennis Oppenheim, for instance, used photographs with texts and maps as a way of documenting their Land Art works, while Richard Long and Hamish Fulton took photographs in the course of their walks, both as a record and to help evoke the particular character of the landscape.

Long and Fulton were students of Caro's at St Martin's School of Art and overlapped there with, among others, Gilbert and George, John Hilliard, Bruce McLean and the Dutch artist Jan Dibbets. Unlike the previous generation of Caro's students such as Phillip King and Tim Scott, they were in reaction against the teaching and against the practice of object making. Gilbert and George decided to work together and called themselves 'living sculptors'; after presenting a few highly stylised performances, they started to use photographs of themselves and their surroundings to depict ordinary, universal experiences and desires, such as aggression, boredom, life in all its beauty and harmony. One such piece is 'Balls' which celebrates their visits to Balls Brothers, a wine bar in the East End of London, and a state of alcoholic inebriation. Hilliard explored the technical functioning of the camera as objectively and systematically as possible in 'Camera Recording its Own Condition', while Dibbets, in works such as 'Panorama Dutch Mountain', took a series of photographs of a flat beach, changing the angle of the camera by a fixed amount for each take, and then mounted the photographs to create a panoramic effect.

Other artists who have used photography in a variety of unconventional ways include Bernhard and Hilla Becher, with their series of photographs of industrial structures; Boyd Webb, who creates strange, almost surreal settings in which he poses his actors; and Arnulf Rainer, who gestures and grimaces theatrically in front of the camera and then draws over the resulting photographs.

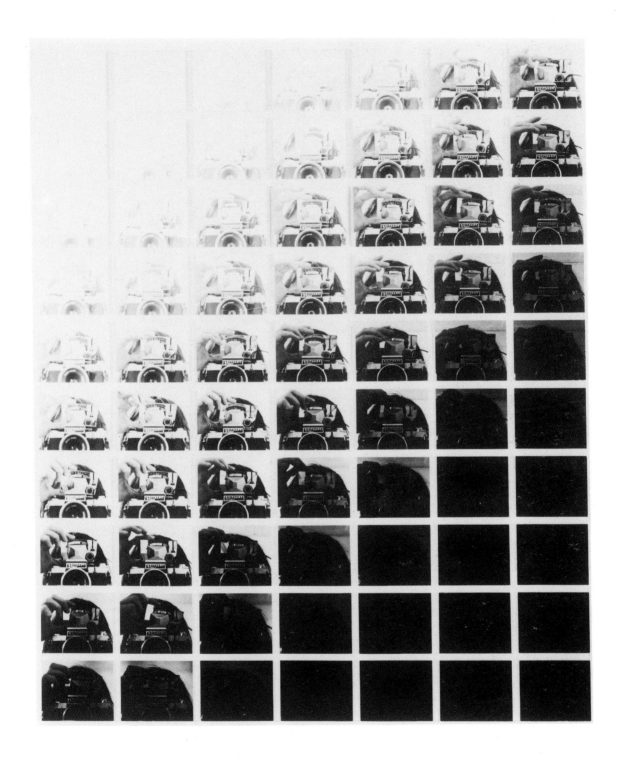

John Hilliard, **Camera Recording its Own Condition
(7 Apertures, 10 Speeds, 2 Mirrors)** 1971

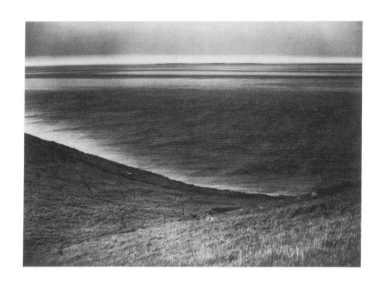

FRANCE ON THE HORIZON · 21 MILES ACROSS THE CHANNEL

A ONE DAY 50 MILE WALK BY WAY OF THE WHITE CLIFFS OF DOVER

ENGLAND SUMMER 1975

Hamish Fulton, **France on the Horizon** 1975

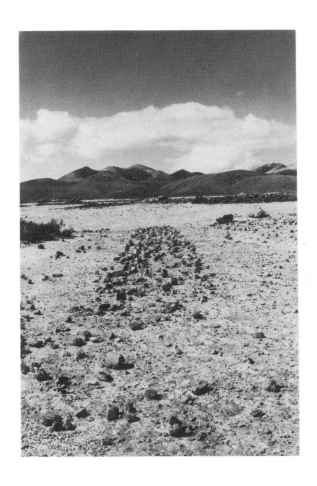

Richard Long, **A Line in Bolivia – Kicked Stones** 1981

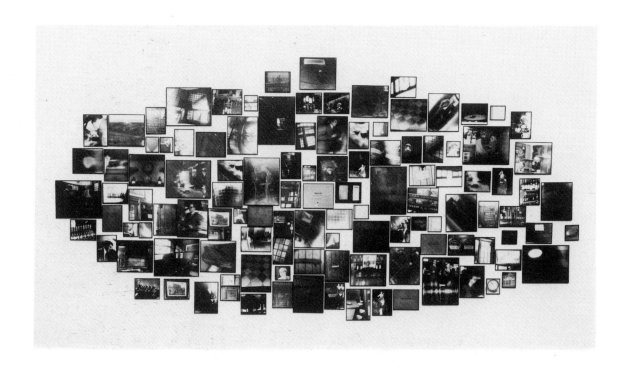

Gilbert and George, **Balls: the evening before
the morning after – Drinking Sculpture** 1972

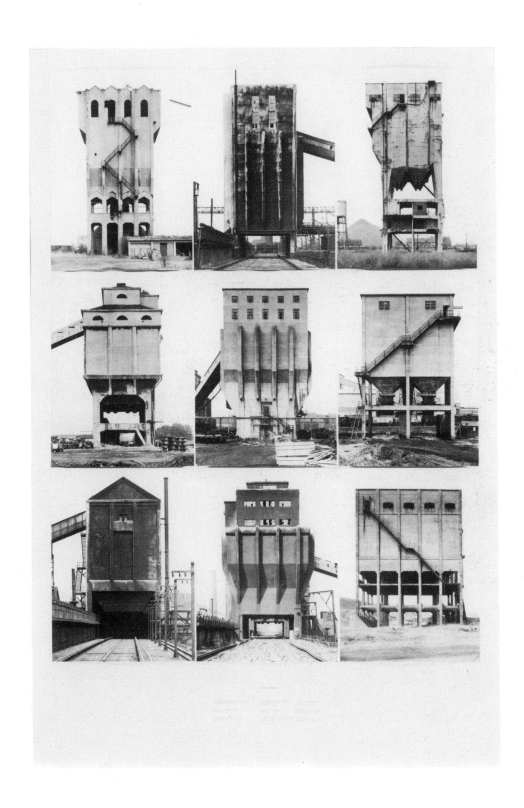

Bernhard and Hilla Becher, **Coal Bunkers** 1974

Post-War Prints

The post-war period has been an exceptionally flourishing and productive one for prints, partly because the enormous escalation in the prices of paintings by leading contemporary artists, placing them beyond the reach of the average collector, has created a large market for less expensive examples of their work produced in editions. This in turn has led to an increase in the number of print publishers and print studios, to which the artists can go for advanced technical assistance. Although there are still some print-makers who carry out the whole operation themselves (mainly those whose works are in relatively straightforward and traditional techniques such as etching), most of the finest prints produced in the last twenty-five years have been made in collaboration with master printers and their highly skilled assistants, and using every kind of modern equipment. This has made possible not only a much richer range of colours, sometimes created by means of a large number of printings with different coloured inks, but has also led to the production of some prints which are of huge size, with the scale and richness of colour of oil paintings.

One of the most important innovations has been the development of screen-printing, which had hitherto been used only for commercial, advertising purposes. This technique, which combines photographic processes with the use of screens and stencils, makes it possible to reproduce photographic images from newspapers and the like, and also to render very exactly the effect of the more hard-edge type of abstract painting, with its clean-cut areas of intense, saturated colour. The potentialities of screen-printing as a print-making technique for artists, on a par with lithography and etching, were first pioneered at the Kelpra Studio in London run by master printer Chris Prater, and have been particularly explored by such artists as Hamilton, Kitaj, Paolozzi and Tilson.

The Tate's print collection was founded only a little over ten years ago by the gift in 1975 from the Institute of Contemporary Prints of a collection of about 3000 prints, all made since 1945 and almost all by British artists. The collection had been formed mainly by gifts from artists, printers and publishers, most of whom have continued to add further works. However there have also been a good many highly selective purchases in order to make the collection better balanced and so as to represent the leading foreign artists.

Jasper Johns, **Sketch from Untitled II** 1974

I went to New York to meet Wittgenstein at the ship. When I first saw him I was surprised at his apparent physical vigour. He was striding down the ramp, with a pack on his back, a heavy suitcase in one hand, cane in the other.

Eduardo Paolozzi, **As is When: Wittgenstein in New York** 1964

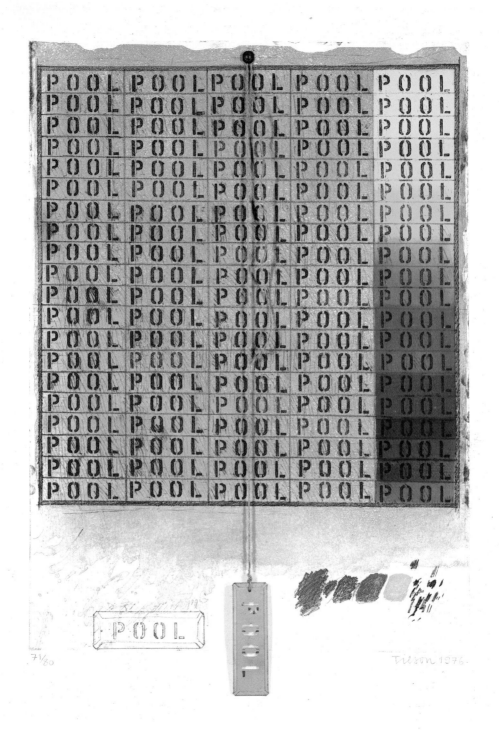

Joe Tilson, **Pool Mantra** 1976

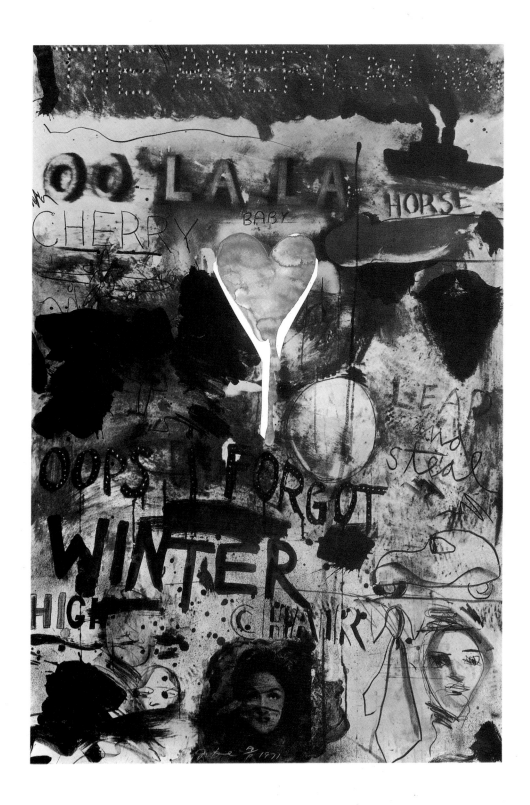

Jim Dine, **Picabia II (Forgot)** 1971

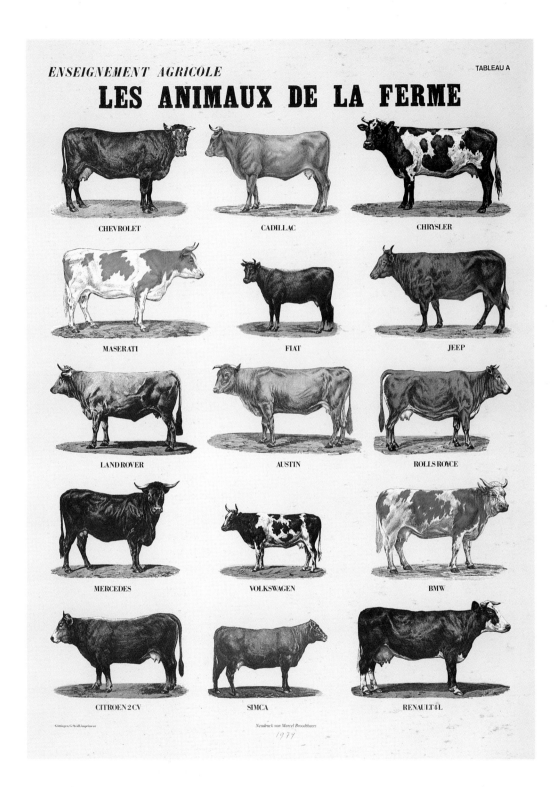

Marcel Broodthaers, **Farm Animals I** 1974

Neo-Expressionism in Recent Painting

The very spare and cerebral abstract art of the 1960s and '70s, both Minimal and colour-field, and the extremes of Conceptual Art, the use of photographs, printed texts and so on, have in turn led to a reaction: an explosive resurgence of expressionistic figure painting. In the last twenty years, and above all since the beginning of the 1980s, a number of young painters in various countries have returned to figure painting which is large in scale, subjective in content, and rough and vigorous in execution. Baselitz, Kiefer, Penck, Lüpertz and others in Germany have played a major pathfinding role in this, reviving to some extent the tradition of German Expressionism, but an important part has also been played by Italian artists such as Chia, Clemente and Cucchi and by artists working in the USA such as Schnabel and Morley. British artists like Christopher LeBrun, Steven Campbell and (in his paintings) Bruce McLean also form part of this tendency. Among their precursors they count not only the German Expressionists and Munch, but the work of Beuys and the late paintings of Picasso, de Chirico and Guston, which had previously been much under-rated.

Painters felt themselves free once again to use myth, religion and mythological themes as material for their paintings, and to indulge in poetry and fantasy; their works are sometimes crowded with complex and mysterious symbolism. Baselitz, who now avoids symbolic subject matter, has worked since 1969 with his images upside down 'to set the imagination free', while Schnabel has painted many of his pictures over a rough surface incorporating quantities of broken pottery, which disrupt the image and make it deliberately difficult to read.

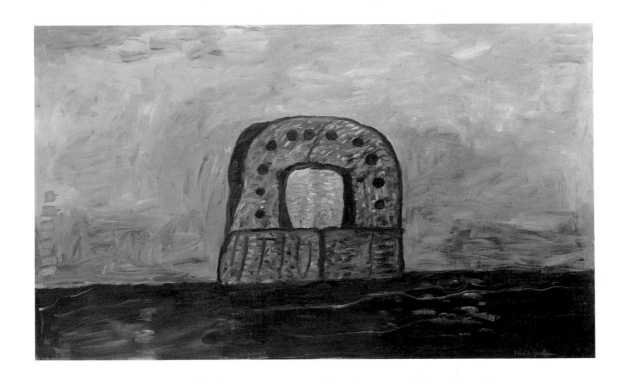

Philip Guston, **Black Sea** 1977

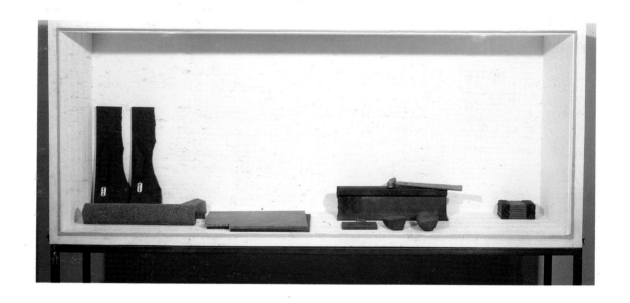

Joseph Beuys, **Untitled (Vitrine)** 1983

Anselm Kiefer, **Parsifal III** 1973

Sandro Chia, **Water Bearer** 1981

Georg Baselitz, **Adieu** 1982

New British Sculpture

One of the most successful aspects of British art since the war has been the emergence of generation after generation of gifted sculptors, each generation different from its predecessors. Thus the sculptors like Phillip King, Tim Scott and William Tucker who studied under Caro at St Martin's School of Art in the late 1950s and beginning of the '60s were succeeded soon afterwards by Gilbert and George, John Hilliard, Hamish Fulton, Richard Long and Barry Flanagan. Though some gave up sculpture in the conventional sense altogether in favour of photography, Long and Flanagan have continued to produce pieces of various kinds. Long not only makes works in the course of his walks by rearranging some of the stones and pieces of wood which he finds along the way into simple, elemental configurations such as lines and circles, but takes the materials into a gallery setting and uses them to make floor sculptures; his works have some affinity with prehistoric stone circles and other early traces of Man's presence in the landscape. Flanagan has experimented with various styles; his recent works include an impishly humorous series of bronzes incorporating the image of a cavorting hare. The sculptures of John Davies, on the other hand, are all based on the human figure and convey a powerful and disturbing sense of unease.

Long, Flanagan and Davies have been followed in turn by a further generation which includes Tony Cragg, Richard Deacon, Anthony Gormley, Anish Kapoor, Nicholas Pope, Julian Opie, Stephen Cox, Bill Woodrow and David Nash (not all of whom can be included in this exhibition for reasons of space). The wide diversity of their styles is an indication of the continuing vitality of sculpture in Britain, and augurs well for the future.

WIMBLEDON SCHOOL OF ART LIBRARY

Richard Deacon, **'For Those Who have Ears' No. 2** 1983

Anish Kapoor, **As if to celebrate, I discovered a mountain blooming with red flowers** 1981

Julian Opie, **Making It** 1983

The Friends of the Tate Gallery

The Friends of the Tate Gallery is a society which aims to help buy works of art that will enrich the collections of the Tate Gallery. It also aims to stimulate interest in all aspects of art.

Although the Tate has an annual purchase grant from the Treasury, this is far short of what is required, so subscriptions and donations from Friends of the Tate are urgently needed to enable the Gallery to improve the National Collection of British painting to 1900 and keep the Modern Collection of painting and sculpture up to date. Since 1958 the Society has raised over £1 million towards the purchase of an impressive list of works of art, and has also received a number of important works from individual donors for presentation to the Gallery.

In 1982 the Patrons of New Art were set up within the Friends' organisation. This group, limited to 200 members, assists the acquisition of works by younger artists for the Tate's Modern Collection.

The Friends are governed by a council – an independent body – although the Director of the Gallery is automatically a member. The Society is incorporated as a company limited by guarantee and recognised as a charity.

Advantages of Membership include:

Special entry to the Gallery at times the public are not admitted. Free entry to, and invitations to private views of, paying exhibitions at the Gallery. Opportunities to attend lectures, private views at other galleries, films, parties, and of making visits in the United Kingdom and abroad organised by the Society. Tate Gallery publications, including greetings cards, etc. and art magazines at reduced prices. Use of the Members' Room in the Gallery.

MEMBERSHIP RATES

any membership can include husband and wife

Benefactor Life Member £5,000 (single donation).
Patron of New Art £325 annually or £250 if a Deed of Covenant is signed.
Patron £250 annually or £200 if a Deed of Covenant is signed.
Corporate £250 annually or £200 if a Deed of Covenant is signed.
Associate £65 annually or £50 if a Deed of Covenant is signed.
Life Member £1,500 (single donation).
Member £15 annually or £12 if a Deed of Covenant is signed.
Educational & Museum £12 annually or £10 if a Deed of Covenant is signed.
Young Friends (under 26) £10 annually.

Subscribing Corporate Bodies as at December 1985

*Agnew & Sons Ltd, Thomas
Alex. Reid & Lefevre Ltd
Allied Irish Banks Ltd
American Express Europe Ltd
†Associated Television Ltd
Balding & Mansell Ltd
Bank of America
†Bankers Trust Company
Barclays Bank International Plc
Baring Foundation, The
*Benson & Partners Ltd, F. R.
*BOC International Ltd
Bowring & Co. Ltd, C. T.
British Council, The
British Petroleum Co. Plc
CCA Stationery Ltd
Cazenove & Co
*Chartered Consolidation Plc
Charterhouse Group
*Christie, Manson & Woods Ltd
Christopher Hull Gallery
Citicorp Investment Bank Ltd
Colnaghi & Co. Ltd, P. & D.
Commercial Union Assurance Plc
Coutts & Company
De la Rue Company Plc
Delta Group Plc
Deutsche Bank AG
*Editions Alecto Ltd
Electricity Council, The
Electronic Data Systems Ltd
Equity & Law Charitable Trust
Esso Petroleum Co. Plc
Farquharson Ltd, Judy
Fine Art Society Ltd

Fischer Fine Art Ltd
Fitton Trust, The
*Gimpel Fils Ltd
Greig Fester Ltd
Guardian Royal Exchange Assurance Group
Guinness Son & Co. Ltd, Arthur
Guinness Peat Group
Hill Samuel Group Plc
IBM UK Ltd
Imperial Chemical Industries Plc
Imperial Group Plc
Kitcat Aitken & Safran Ltd
Kleinwort Benson Ltd
Knoedler Kasmin Ltd
Lazard Brothers & Co. Ltd
*Leger Galleries Ltd
Lewis & Co. Ltd, John
Lumley Cazalet Ltd
Madame Tussauds Ltd
†Manor Charitable Trustees
*Marks & Spencer Plc
Market & Opinion Research Int. Ltd
Marlborough Fine Art Ltd
*Mayor Gallery, The
Minsky's Gallery
Montagu & Co. Ltd, Samuel
Morgan Bank
Morgan, Grenfell & Co. Ltd
National Westminster Bank Plc
Ocean Transport Trading Ltd
*Ove Arup Partnership
Pearson Plc
Peter Moores Foundation
Phillips Petroleum Co. Europe-Africa

Phillips Son & Neal
Piccadilly Gallery
Plessey Company Plc, The
Postcard Gallery, The
Rayne Foundation, The
Redfern Gallery
†Rediffusion Television Ltd
Richard Green Gallery
Roberts & Hiscox Ltd
Roland, Browse & Delbanco
Rothschild & Sons Ltd, N. M.
RTZ Services Ltd
Schroder, Wagg & Co. Ltd, J. Henry
Schupf, Woltman & Co. Inc.
Sinclair Montrose Trust
Smith & Son Ltd, W. H.
Somerville & Simpson Ltd
Sotheby Parke Bernet & Co.
Spink & Son Ltd
Stephenson Harwood
Sun Alliance & London Insurance Group
Swan Hellenic Art Treasure Tours
Swire & Sons Ltd, John
*Tate & Lyle Ltd
Thames & Hudson Ltd
†Tramman Trust
*Ultramar Plc
Vickers Ltd
*Waddington Galleries Ltd
Willis Faber Plc
Winsor & Newton

*By Deed of Covenant
†Life member

for further information apply to:

The Friends of the Tate Gallery, Tate Gallery, Millbank, London SW1P 4RG Telephone: 01-821 1313 or 01-834 2742